or before

...ow. 759.06

Amedeo Modigliani

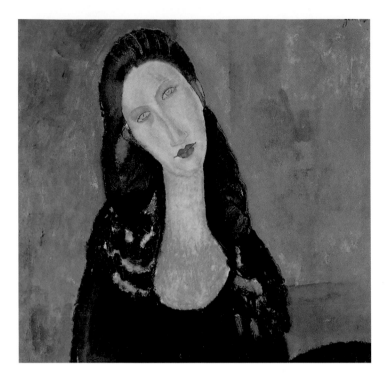

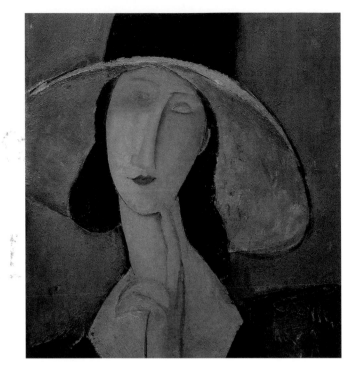

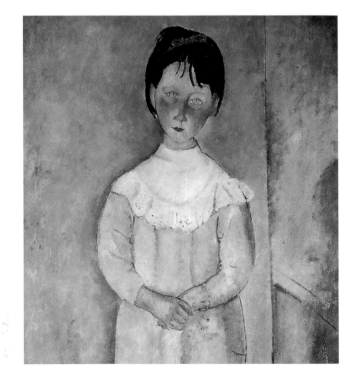

© Confidential Concepts, worldwide, USA, 2004
© Sirrocco, London, 2004 (English version)

Published in 2004 by Grange Books
an imprint of Grange Books Plc
The Grange Kingsnorth Industrial Estate
Hoo, nr Rochester Kent ME3 9ND
www.Grangebooks.co.uk
ISBN 1-84013-661-8
Printed in China

Amedeo

Modigliani

WOODMILL HIGH SCHOOL

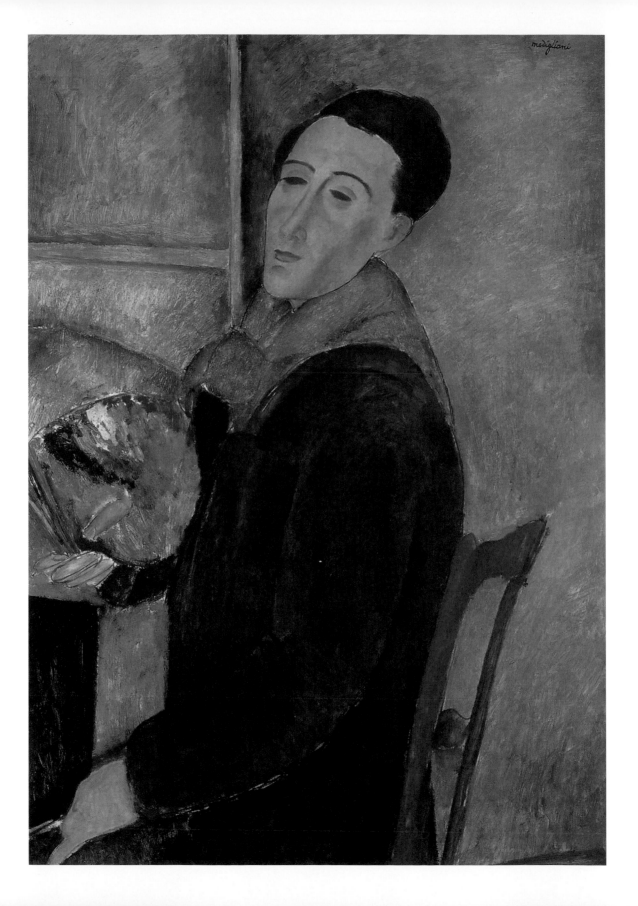

Amedeo Modigliani was born in Italy in 1884 and died in Paris at the age of thirty-five. He was Jewish, with a French mother and Italian father, and so grew up amidst three cultures. A passionate and charming man who had numerous lovers, his unique vision was nurtured by his appreciation of his Italian and classical artistic heritage, his understanding of French style and sensibility, in particular the rich artistic atmosphere of Paris at the turn of the 20th century, and his intellectual awareness inspired by Jewish tradition.

Unlike other avant-garde artists, Modigliani painted mainly portraits – typically unrealistically elongated with a melancholic air – and nudes, which exhibit a graceful beauty and strange eroticism.

In 1906, Modigliani moved to Paris, the centre of artistic innovation and the international art market. He frequented the cafes and galleries of Montmartre and Montparnasse, where many different groups of artists congregated. He soon became friends with the post-impressionist painter (and alcoholic) Maurice Utrillo (1883–1955) and the German painter Ludwig Meidner (1844–1966), who described Modigliani as the "last, true bohemian" (Doris Krystof, *Modigliani*).

Modigliani's mother sent him what money she could afford, but he was desperately poor and had to change lodgings frequently, sometimes abandoning his work when he had to run away without paying the rent. Fernande Olivier, the first girlfriend in Paris of Pablo Picasso (1881–1973), describes one of Modigliani's rooms in her book *Picasso and his Friends* (1933): "A stand on four feet in one corner of the room. A small and rusty stove on top of which was a yellow terracotta bowl that was used for washing in; close by lay a towel and a piece of soap on a white wooden table. In another corner, a small and dingy box-chest painted black was used as an uncomfortable sofa. A straw-seated chair, easels, canvases of all sizes, tubes of colour spilt on the floor, brushes, containers for turpentine, a bowl for nitric acid (used for etchings), and no curtains."

Modigliani was a well-known figure at the Bateau-Lavoir, the celebrated building where many artists, including Picasso, had their studios. It was probably given its name by the bohemian writer and friend of both Modigliani and Picasso, Max Jacob (1876–1944).

1. *Self-Portrait*, 1919.
Oil on canvas,
100 x 65 cm.
Museu de Arte
Contemporanea da
Universidade de San
Paulo, Brazil.

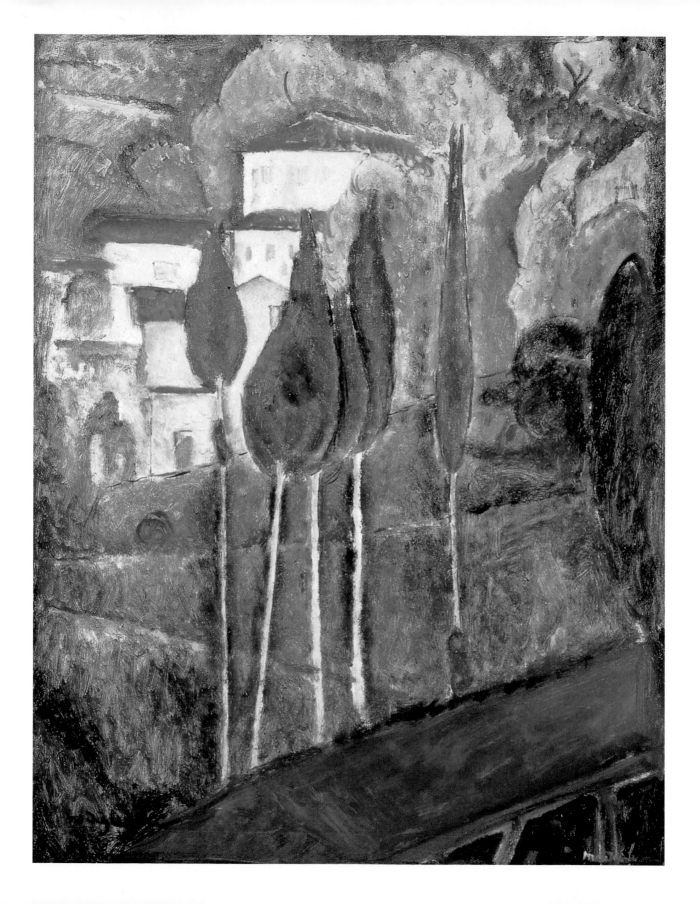

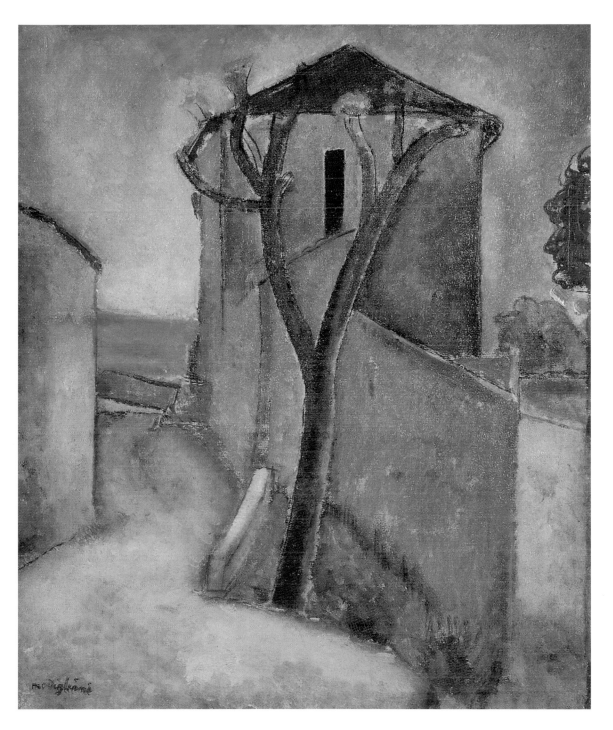

2. *Landscape in the Midi*,
 1919.
 Oil on canvas,
 60 x 45 cm.
 Private collection.

3. *Tree and Houses*,
 1919.
 Oil on canvas,
 57 x 45 cm.
 Private collection.

While at the Bateau-Lavoir, Picasso painted *Les Demoiselles d'Avignon* (1907), the radical depiction of a group of prostitutes that heralded the start of Cubism.

Other Bateau-Lavoir painters, such as Georges Braque (1882–1963), Jean Metzinger (1883–1956), Marie Laurencin (1885–1956), Louis Marcoussis (1883–1941), and the sculptors Juan Gris (1887–1927), Jacques Lipchitz (1891–1973) and Henri Laurens (1885–1954) were also at the forefront of Cubism.

The vivid colours and free style of Fauvism had just become popular and Modigliani knew the Bateau-Lavoir Fauves, including André Derain (1880–1954) and Maurice de Vlaminck (1876–1958), as well as the Expressionist sculptor Manolo (Manuel Martinez Hugué; 1876–1945), and Chaim Soutine (1893–1943), Moïse Kisling (1891–1953), and Marc Chagall (1887–1985). Modigliani painted portraits of many of these artists.

Max Jacob and other writers were drawn to this community. These included the poet and art critic (and lover of Marie Laurencin) Guillaume Apollinaire (1880–1918), the Surrealist Alfred Jarry (1873–1907), the writer, philosopher and photographer Jean Cocteau (1889–1963), with whom Modigliani had a mixed relationship, and André Salmon (1881–1969), who went on to write a dramatized novel based on Modigliani's unconventional life. The American writer and art collector Gertrude Stein (1874–1946) and her brother Leo were also regular visitors.

Modigliani was known as "Modi" to his friends, no doubt a pun on *peintre maudit* (accursed painter). He himself believed that the artist had different needs and desires, and should be judged differently from other, ordinary, people – a theory he came upon by reading such authors as Friedrich Nietzsche (1844–1900), Charles Baudelaire (1821–1867), and Gabriele D'Annunzio (1863–1938). Modigliani had countless lovers, drank copiously, and took drugs. From time to time, however, he also returned to Italy to visit his family and to rest and recuperate.

4. *Nude*, circa 1908.
 Oil on canvas,
 61 x 38 cm.
 Perls Gallery,
 New York.

In childhood, Modigliani had suffered from pleurisy and typhoid, leaving him with damaged lungs. His precarious state of health was exacerbated by his lack of money and unsettled, self-indulgent lifestyle. He died of tuberculosis; his young fiancée, Jeanne Hébuterne, pregnant with their second child, was unable to bear life without him and killed herself on the following morning.

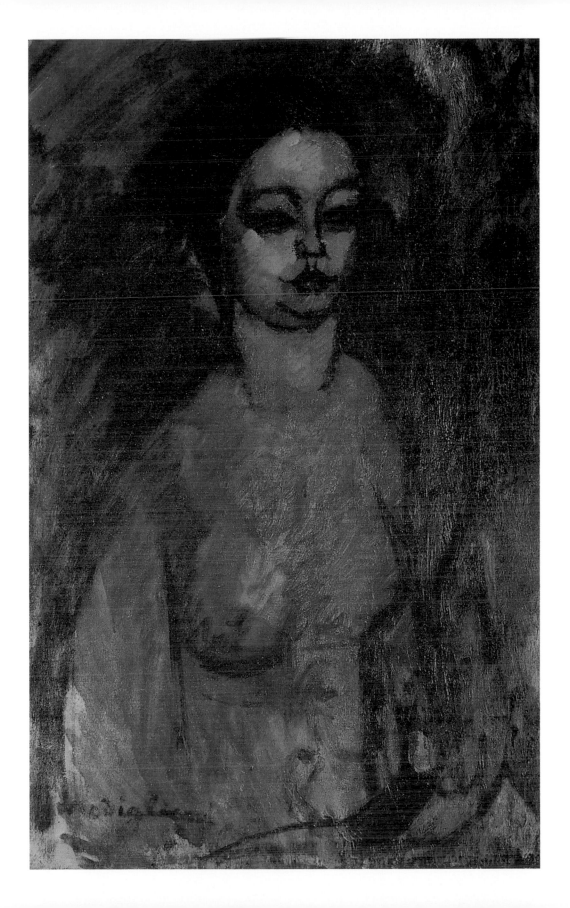

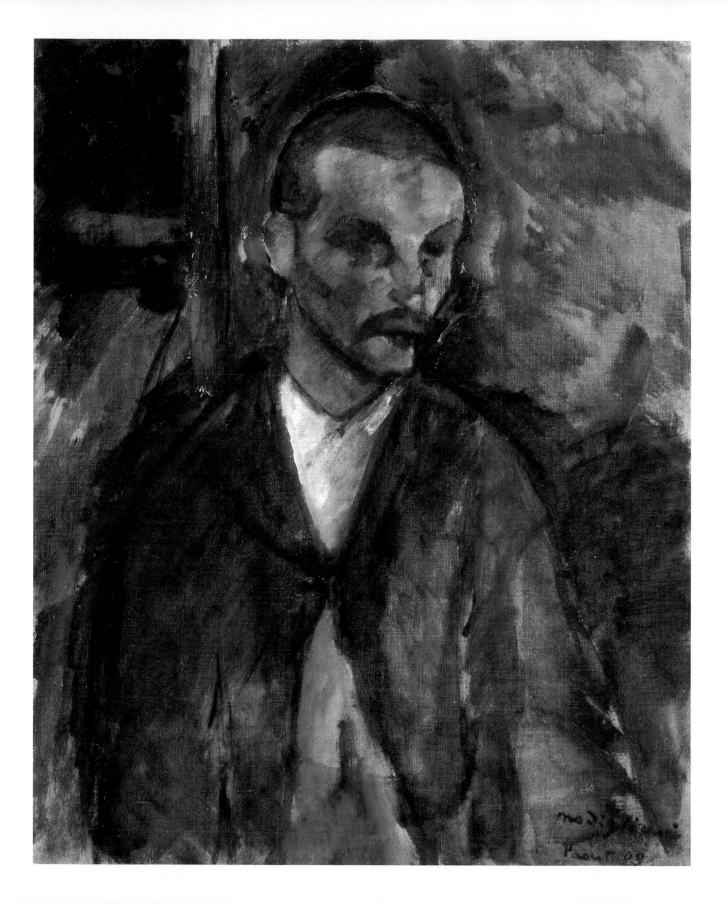

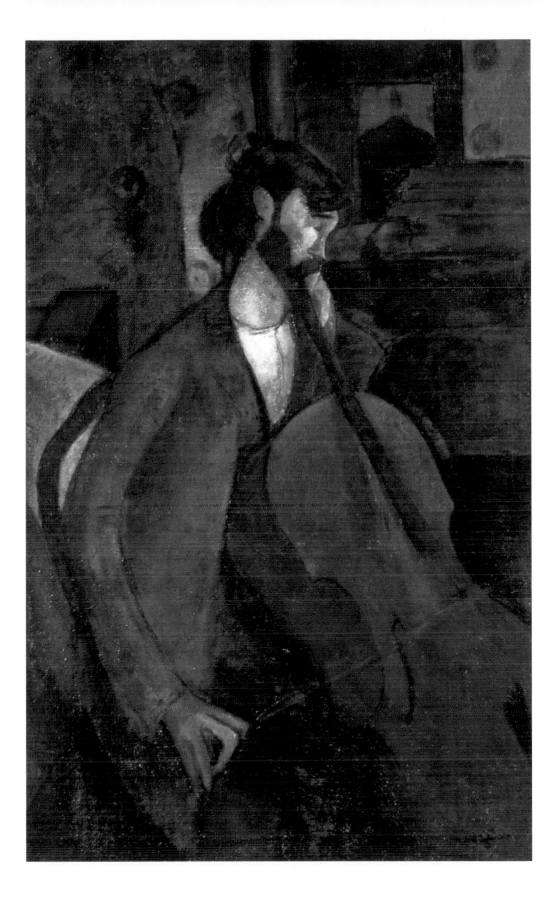

5. **The Beggar of Livorno**, 1909.
Oil on canvas,
66 x 52,7 cm.
Private collection.

6. **The Cellist**, 1909.
Oil on canvas,
130 x 80 cm.
Private collection.

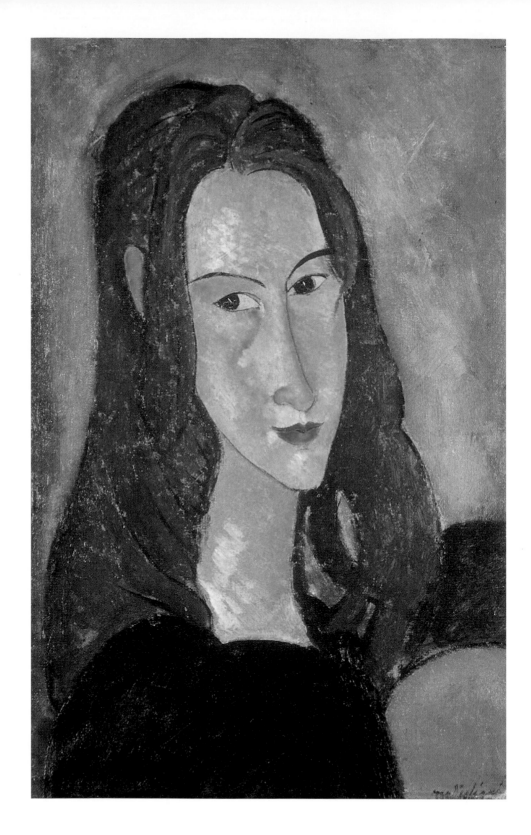

7. ***Portrait of Jeanne Hébuterne - Head in profile (Young Redhead)***, 1918. Oil on canvas, 46 x 29 cm. Private collection.

8. ***Female Nude with Hat***, 1907-08. Oil on canvas, 80,6 x 50,1 cm. Reuben and Edith Hecht Museum, University of Haïfa, Israel.

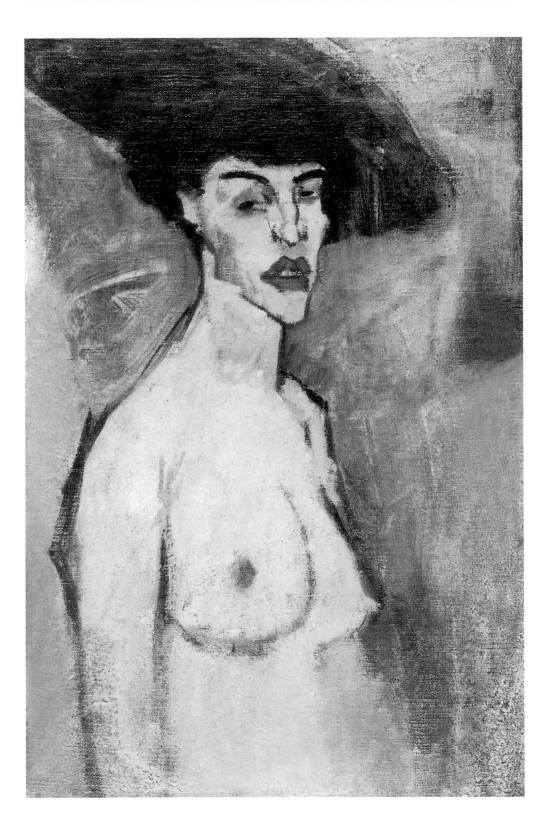

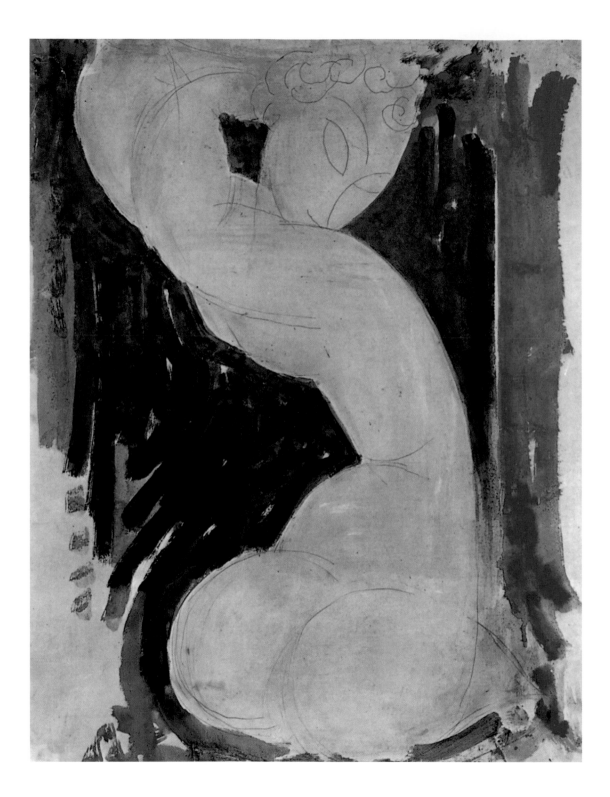

From Tradition to Modernism
A Reinterpretation of Classical Works

Modigliani's first teacher, Guglielmo Micheli (died 1926), was a follower of the Macchiaioli school of Italian Impressionists. Modigliani learned both to observe nature and to understand observation as pure sensation. He took traditional life-drawing classes and immersed himself in Italian art history. From an early age he was interested in nude studies and in the classical notion of ideal beauty.

In 1900–1901 he visited Naples, Capri, Amalfi, and Rome, returning by way of Florence and Venice, and studied firsthand many Renaissance masterpieces. He was impressed by trecento (13th century) artists, including Simone Martini (c.1284–1344), whose elongated and serpentine figures, rendered with a delicacy of composition and colour and suffused with tender sadness, were a precursor to the sinuous line and luminosity evident in the work of Sandro Botticelli (c.1445–1510). Both artists clearly influenced Modigliani, who used the pose of Botticelli's Venus in *The Birth of Venus* (1482) in his *Standing Nude (Venus)* (1917) and *Red-Haired Young Woman with Chemise* (1918, p.16), and a reversal of this pose in *Seated Nude with Necklace* (1917, p.17).

The sculptures of Tino di Camaino (c.1285–1337) with their mixture of weightiness and spirituality, characteristic oblique positioning of the head and blank almond eyes also fired Modigliani's imagination. His distorted composition and overly lengthened figures have been compared to those of the Renaissance Mannerists, especially Parmigianino (1503–1540) and El Greco (1541–1614). Modigliani's non-naturalistic use of colour and space are similar to the work of Jacopo da Pontormo (1494–1557).

For his series of nudes, Modigliani took compositions from many well-known nudes of High Art, including those by Giorgione (c.1477–1510), Titian (c.1488–1576), Jean-Auguste-Dominique Ingres (1780–1867), and Velazquez (1599–1660), but avoided their romanticization and elaborate decorativeness. Modigliani was also familiar with the work of Francisco de Goya y Lucientes (1746–1828) and Edouard Manet (1832–1883), who had caused controversy by painting real, individual women as nudes, breaking the artistic conventions of setting nudes in mythological, allegorical, or historical scenes.

9. *Caryatid*, 1913-14.
 Pencil and tempera on paper,
 90 x 70 cm.
 Private collection.

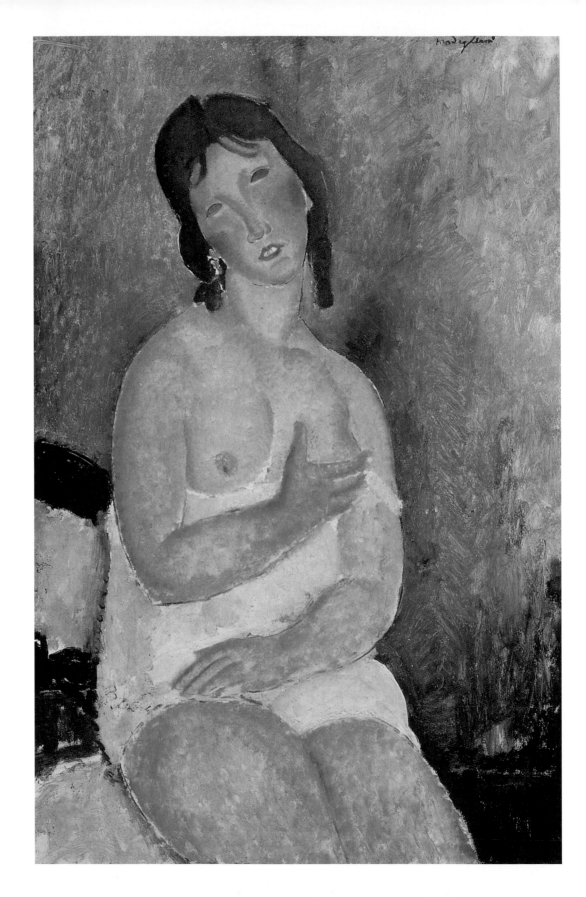

10. *Red-Haired Young Woman in Chemise*, 1918.
Oil on canvas,
100 x 65 cm.
Private collection.

11. *Seated Nude with Necklace*, 1917.
Oil on canvas,
92 x 60 cm.
Private collection.

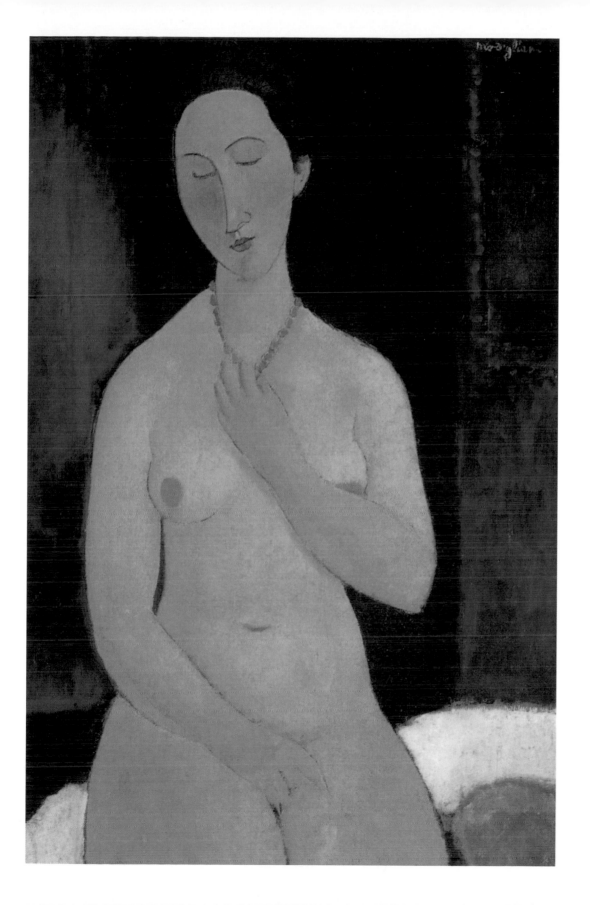

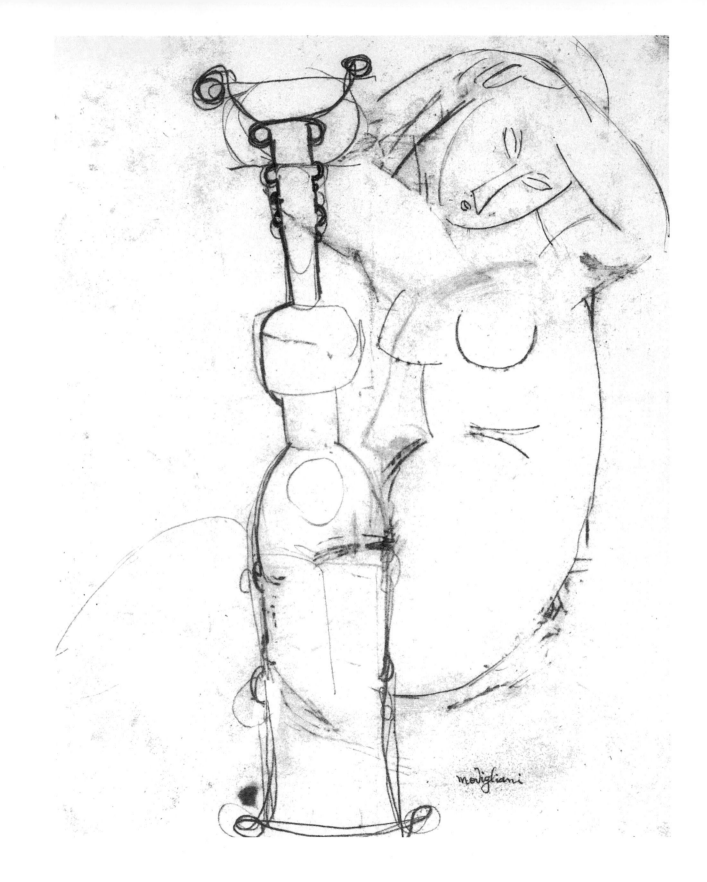

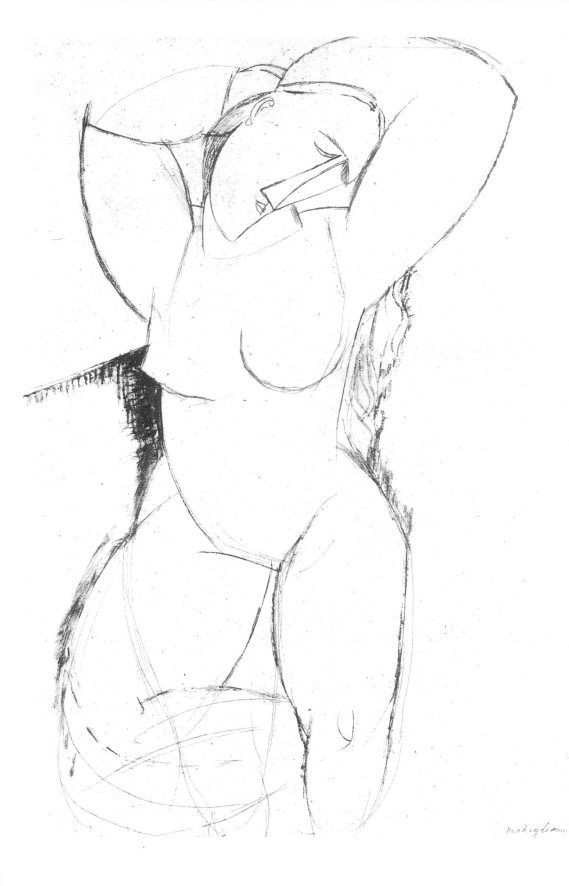

12. ***Sheet of Studies with
African Sculpture
and Caryatid***,
circa 1912/13.
Pencil,
26,5 x 20,5 cm.
Mr. and Mrs. James
W. Alsdorf, Chicago.

13. ***Caryatid Study***,
circa 1913.
Ink and pencil.
Private collection.

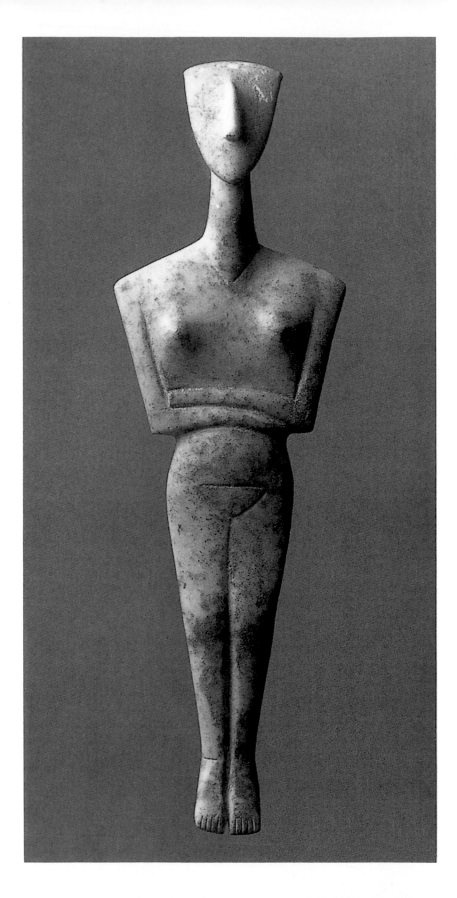

14. ***Idol***, Cyclades,
 Naxos, Greece.
 2700-2400 BC.
 Marble.
 The Mencil
 Collection, Houston.

15. ***Standing Figure***,
 circa 1912/13.
 Limestone,
 163 x 32 x 30 cm.
 Australian National
 Gallery, Canberra.

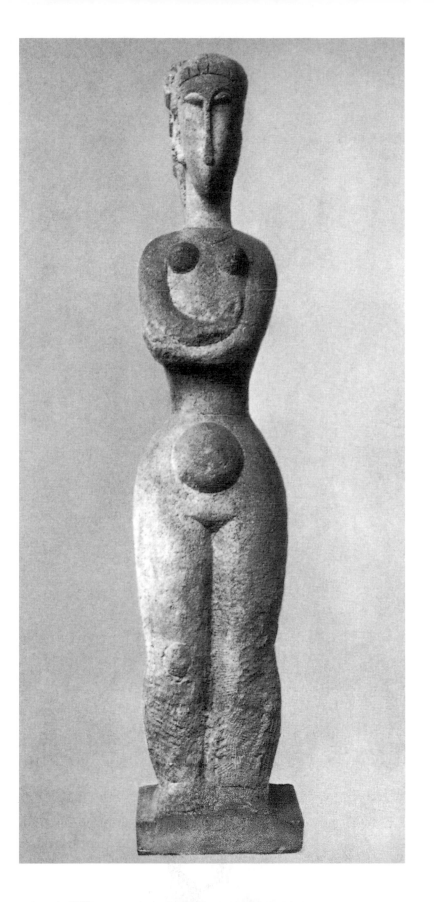

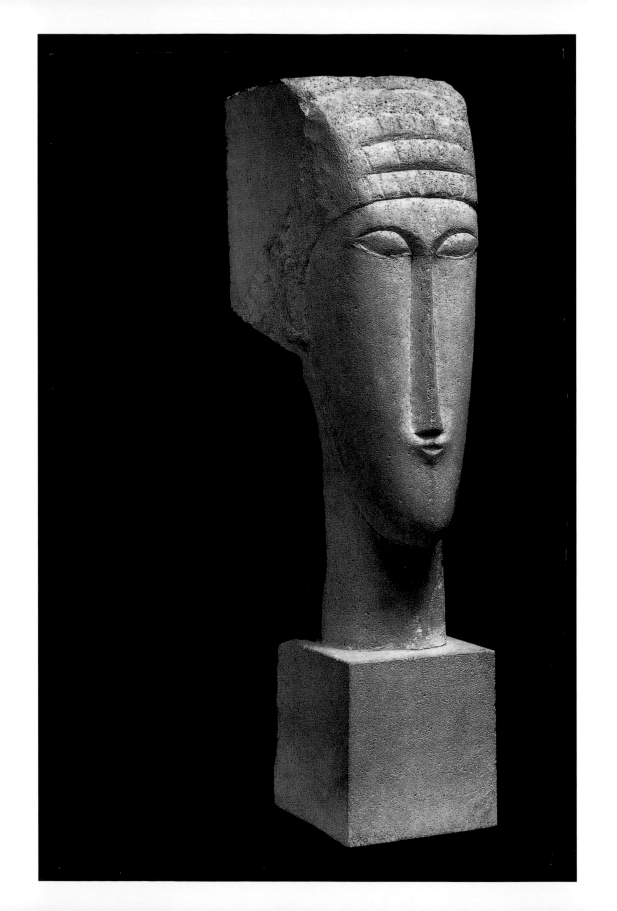

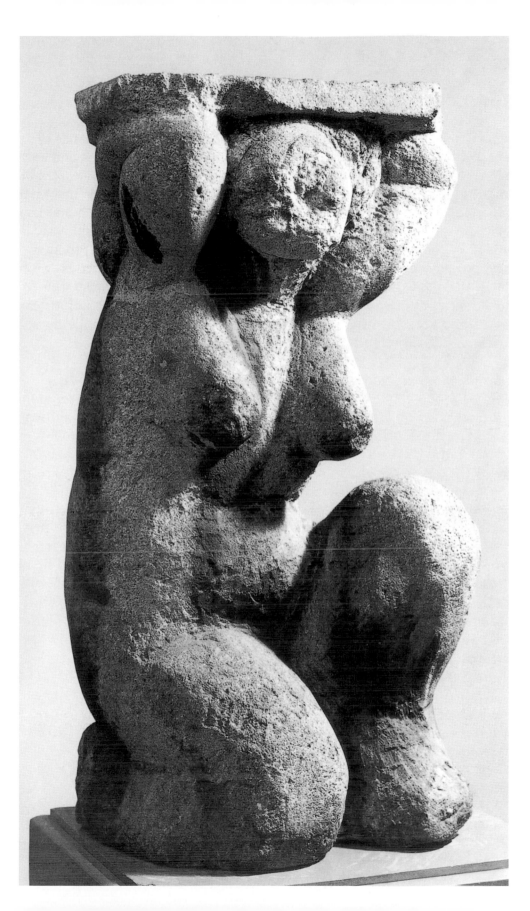

16. ***Head***, 1911-13.
 Sandstone,
 64 x 15 x 21 cm.
 Solomon
 R. Guggenheim
 Museum, New York.

17. ***Caryatid***, 1914.
 Limestone,
 92 x 42 x 43 cm.
 The Museum of
 Modern Art, Simon
 Guggenheim Fund,
 New York.

Discovery of New Art Forms

Modigliani's debt to the art of the past was transformed by the influence of ancient art, the art of other cultures, and Cubism. African sculptures and early ancient Greek Cycladic figures had become very fashionable in the Parisian art world at the turn of the century. Picasso imported numerous African masks and sculptures, and the combination of their simplified abstract approach and use of multiple viewpoints were the direct inspiration for Cubism. Modigliani was impressed by the way the African sculptors unified solid masses to produce abstract but pleasing forms that were decorative but had no extraneous detailing. His interest in such work is illustrated by his *Sheet of Studies with African Sculpture and Caryatid* (c.1912/13, p.18). He sculpted a series of African-inspired stone heads (c.1911–1914), which he called "columns of tenderness," and envisaged them as part of a "temple of beauty."

His friend, the Romanian sculptor Constantin Brancusi (1876–1957), introduced Modigliani to early ancient Greek Cycladic figures. These, along with Brancusi's own work, inspired Modigliani's caryatids. Modigliani was interested in the depiction of solidity, yet caryatids as weight-bearing structures must be powerful as well as graceful. The details in Modigliani's caryatids, however, show a modern awareness of sexuality and a desire to render a sense of the fleshy femininity of the figures.
Caryatid (c.1914, p.29) has her arms behind her head in a pose more often associated with sleep and foreshadows the pose of *Sleeping Nude with Arms Open (Red Nude)* (1917, p.38). The caryatid narrows at the waist, but her belly and full thighs are massive and reflect her full, round arms and head. Her pose echoes Renaissance use of contrapposto and shows Modigliani's awareness of the pliability of her flesh and the sensuousness of her fully curved figure. The *Pink Caryatids* (1913 and 1913–1914, p.36) have even fuller curves and display a lush use of luminous colour. They are essentially patterns of circles and are highly geometric. It was the Cubist approach, developing the ideas of Cézanne, that led Modigliani to stylize the caryatids into such geometric shapes. Their balanced circles and curves, despite having a voluptuousness, are carefully patterned rather than naturalistic. Their curves are precursors of the swinging lines and geometric approach that Modigliani later used in such nudes as *Reclining Nude* (p.40). Modigliani's drawings of caryatids allowed him to explore the decorative potential of poses that may not have been possible to create in sculpture.

18. *Standing Nude*,
1911/12.
Oil on cardboard on wood,
82,8 x 47,9 cm.
Nagoya City Art Museum, Japan.

WOODMILL HIGH SCHOOL

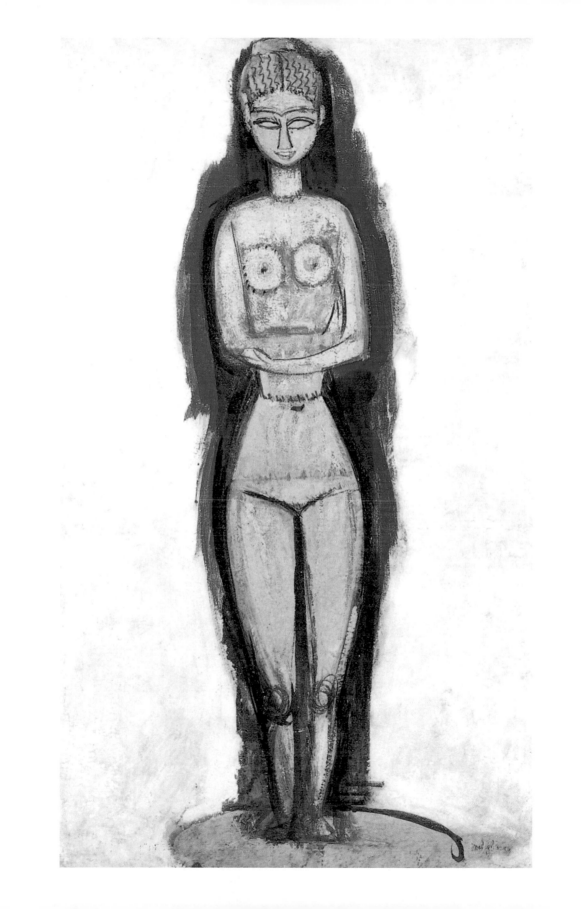

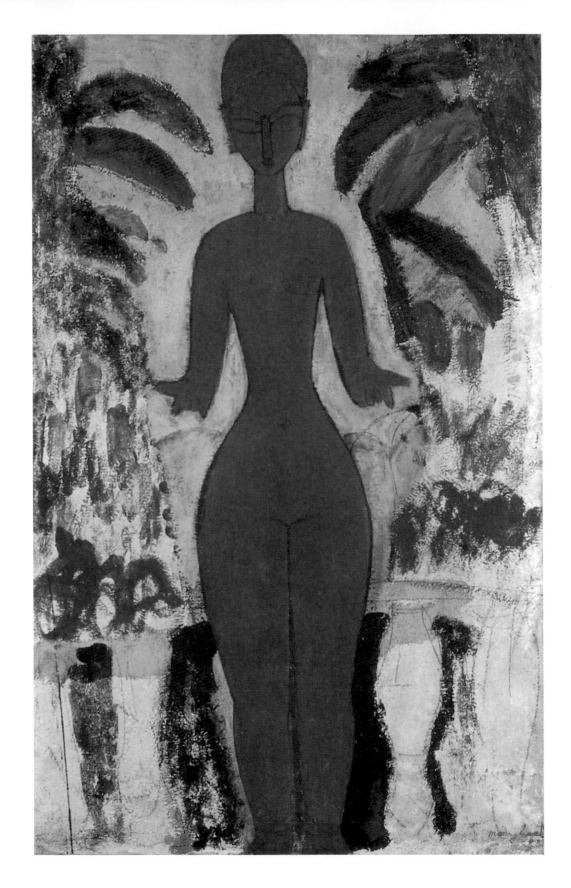

19. *Standing Nude with Garden Background*, 1913.
Oil on board, 81 x 50 cm.
Private collection.

20. *The Red Bust*, 1913.
Oil on cardboard, 81,5 x 51 cm.
Private collection.

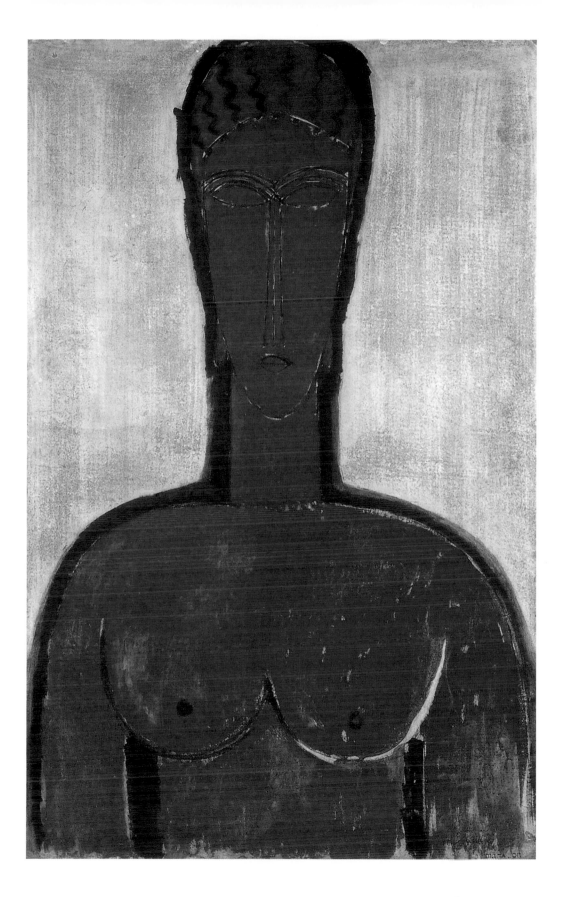

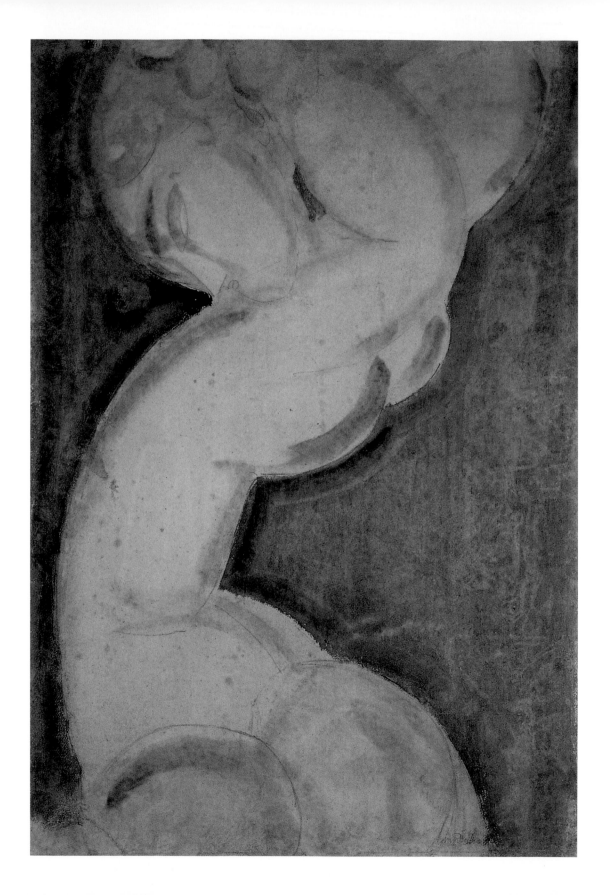

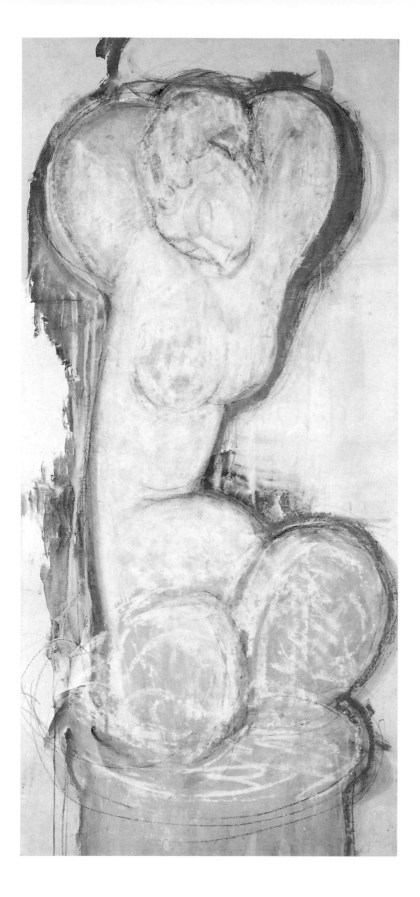

21. *Blue Caryatid*,
 Coloured pencil,
 watercolour and
 gouache on paper,
 73 x 50 cm.
 Private collection.

22. *Caryatid*, circa 1914.
 Gouache on canvas
 and wood,
 140,7 x 66,7 cm.
 The Museum of Fine
 Arts, Houston.

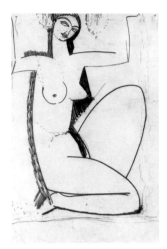

The raised arms of *Caryatid* (1911/1912, p.31) give her a stylized, ballet posture. She is more angular and lean than most of Modigliani's caryatids, apart from her fully rounded breasts and the curving outline to her hip and thigh. *Caryatid* (1910/1911; charcoal sketch) has a similar angled head and uplifted leg. In *Caryatid* (c.1912/1913) Modigliani has emphasized the raised thigh and pointed breast, showing his intention to present the figure as a sexual female.

Caryatid (1912, p.32) faces the viewer and can be seen as a predecessor of Modigliani's standing nudes. The geometrizing of the figure is apparent, as is the reduction to simple forms. *Caryatid* (1913, p.33) is a more highly worked version with fine detailing on the nipples and navel. The slight curve of the right leg where it bends at the knee is an enlivening and humanizing detail. The curious patterned lines across her belly suggest necklaces and emphasize the cone shape of her abdomen and the sexual triangle at the top of her thighs.

The *Standing Nude* (1911/1912, p.25) no longer functions as a caryatid and is a true nude study, showing an architectural approach to the body. Her folded arms frame her heavily outlined breasts, while her face remains abstract and Africanized. The sketch of the *Seated Nude* (c.1910/1911) is a fully realized nude drawing and shows the completion of Modigliani's transition from the caryatids to the true nudes. He allows the lines of the figure's body to swing in a more expressive approach to her eroticism. Only one caryatid sculpture, *Caryatid* (1914, p.23), in limestone has survived. It is rough-hewn unlike the stone heads, so Modigliani may have abandoned it without finishing it, or possibly left it unrefined to give it a powerful appearance. Although her pose is similar to the caryatid drawings, the forms are massive and bulky, and less geometrical and more naturalistic in detailing. The treatment of the breasts and stomach show Modigliani's understanding of the underlying musculature and his interest in resolving solid forms at awkward points, such as the area between the breast, neck and arm.

The influences of Cézanne and Expressionism are clear in the harshness of the *Nudo Dolente* (1908, p.34), one of Modigliani's early nudes, which lacks the luxuriant sexuality of his later nudes. It is a disturbing rather than attractive image although the figure's upturned face with full, slightly parted lips and half-closed eyes hint at a state of frenzy, perhaps agony, perhaps pleasure. The painting illustrates Modigliani's willingness to experiment stylistically and express his intensity and passion.

23. *Caryatid*,
circa 1912/13.
Pencil,
39,7 x 25,7 cm.
Musée des Beaux-
Arts, Dijon, Donation
by Granville.

24. *Caryatid*, 1911/12.
Oil on canvas,
72,5 x 50 cm.
Kunstsammlung
Nordrhein-Westfalen,
Düsseldorf.

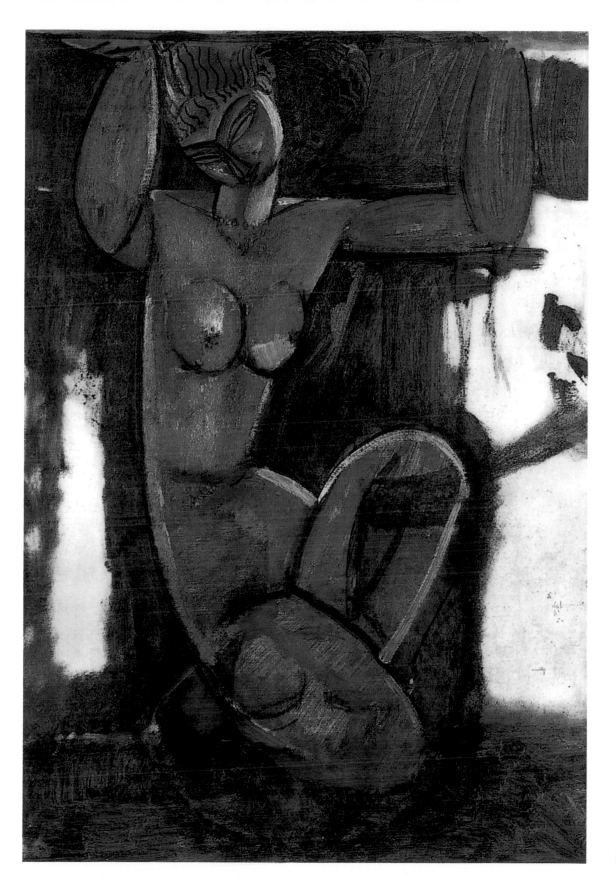

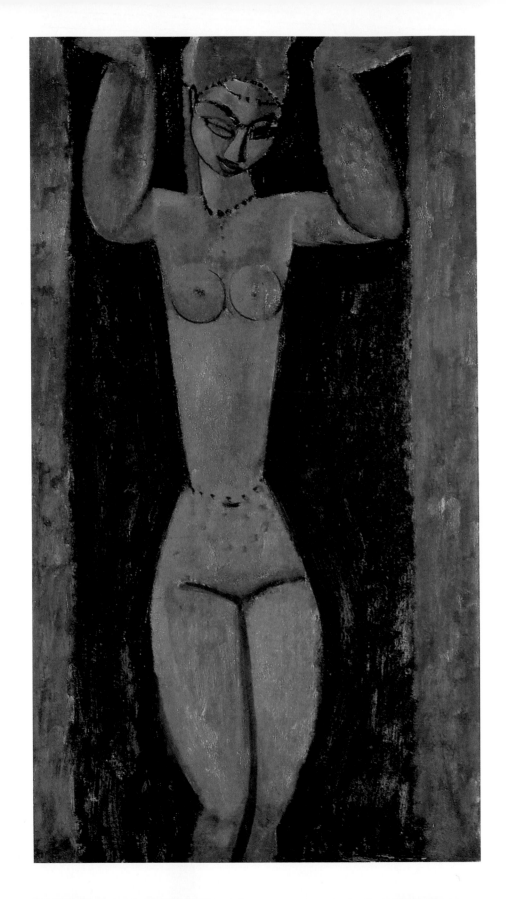

25. *Caryatid*, circa 1912.
Oil on canvas,
81 x 46 cm.
The Sogetsu Art
Museum, Tokyo.

26. *Caryatid*, 1913.
Oil on canvas,
81 x 46 cm.
Collection Samir
Traboulsi.

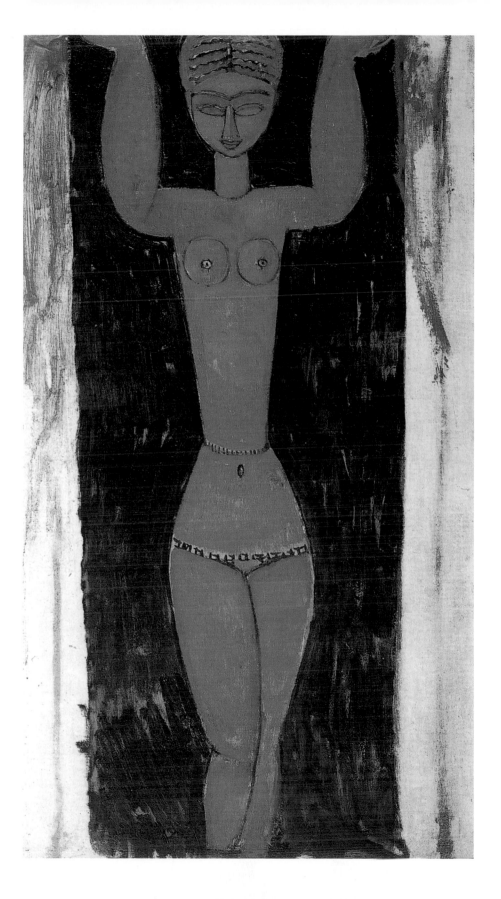

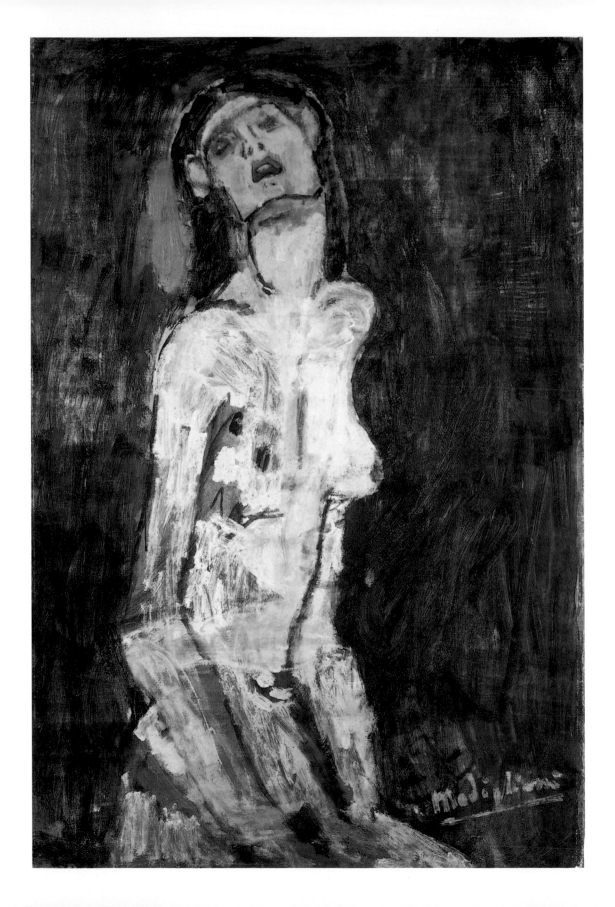

In 1909 Modigliani, like many other artists at that time, moved to Montparnasse, where his friend Brancusi lived. The *Café du Dome* on the south side of Montparnasse Boulevard was especially popular with German artists, while the *Café de La Rotonde* on the north side of the boulevard was a favourite haunt of the Japanese painter Tsuguhara Fujita (born 1886) and his friends.

The influence of the innovative painters of the late 19th century, such as Paul Gauguin (1848–1903) and "Le Douanier" Henri Rousseau (1844–1910), could still be felt, while younger artists, such as André Derain and the Fauves, Pablo Picasso, Ossip Zadkine (1890–1967) and the Cubists, were creating their own styles.

The exchange of ideas must have been phenomenal, and art dealers and collectors, such as Paul Guillaume (1891–1934), whom Modigliani met in 1914, and Leopold Zborowski (1889–1932), who became friends with Modigliani in 1916, also frequented the area. Amidst this hotbed of ideas, Modigliani came to understand many styles before finding his own path. So fast was the pace of innovation that by the time Modigliani was developing his African-influenced Cubist style, the original Cubists were pursuing new ideas.

In his sketch *Caryatid Study* (p.19) a clear similarity to Picasso's *Les Demoiselles d'Avignon* can be seen in the angular pose, weighty raised arms, and use of differing viewpoints.

The Nudes and Moral Values

Modigliani was fascinated by the way that outline can be used to represent volume. He wanted to translate the solidity of sculpture onto flat canvas while capturing the essence of classical elegance. This unwillingness to abandon the past led to criticism of his work by his avant-garde contemporaries, the Futurists, whose manifesto he had refused to sign.

The Futurists believed that art should concern itself only with modern styles and themes, such as machinery and motor cars. They thought Modigliani's paintings were too old-fashioned and they rejected the female nude because it was one of the standard subjects of traditional art. However, Modigliani's approach to the nude was so individual and innovative that traditionalists were shocked by his work.

27. *Nude (Nudo Dolente)*,
1908.
Oil on canvas,
81 x 54 cm.
Richard Nathanson,
London.

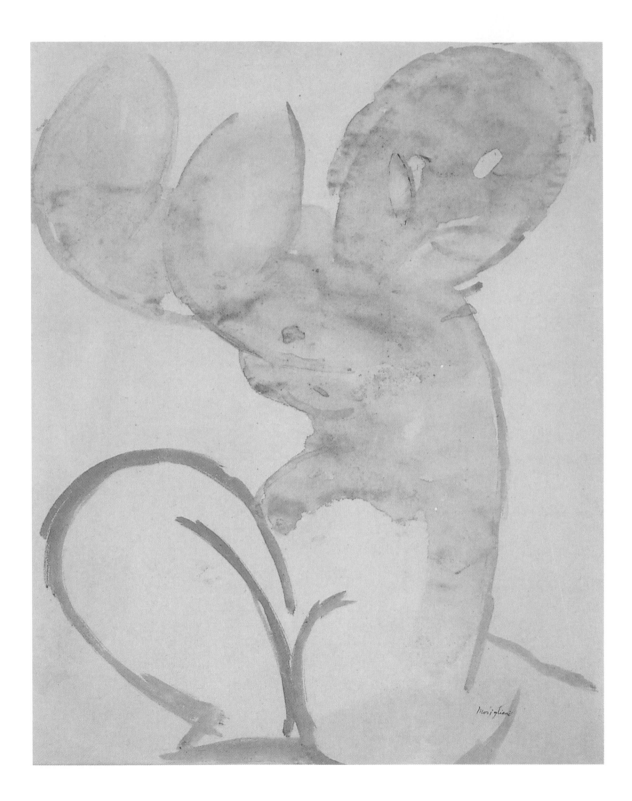

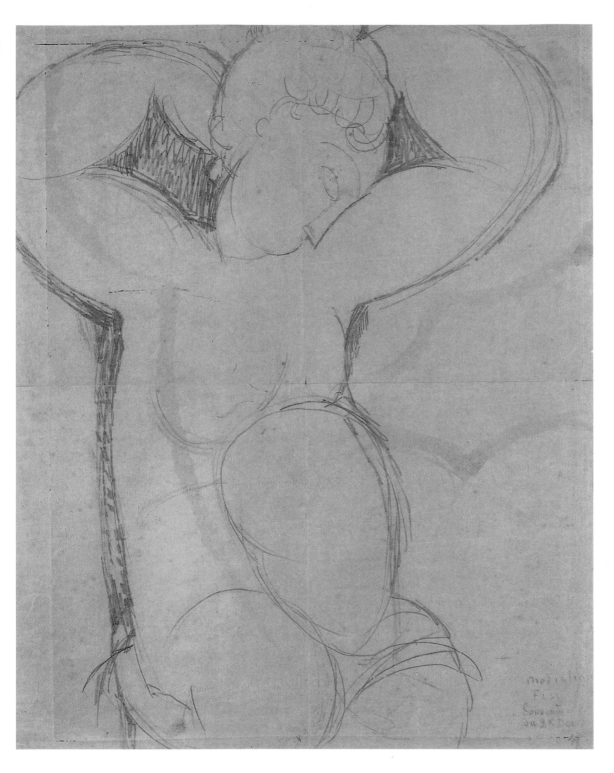

28. **Pink Caryatid**,
 1913/14.
 Watercolour,
 54,6 x 43 cm.
 Collection Evelyn
 Sharp.

29. **Caryatid**.
 Blue soft lead pencil,
 enhanced with red
 chalk, on beige paper,
 56,2 x 45,1 cm.
 Private collection.

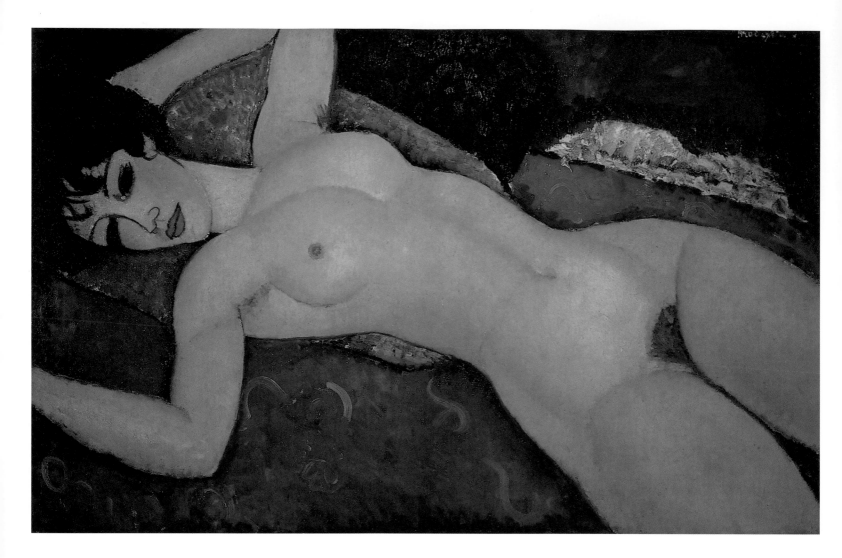

30. *Sleeping Nude with
Arms Open
(Red Nude)*,
circa 1917.
Oil on canvas,
60 x 92 cm.
Collection Gianni
Mattioli.

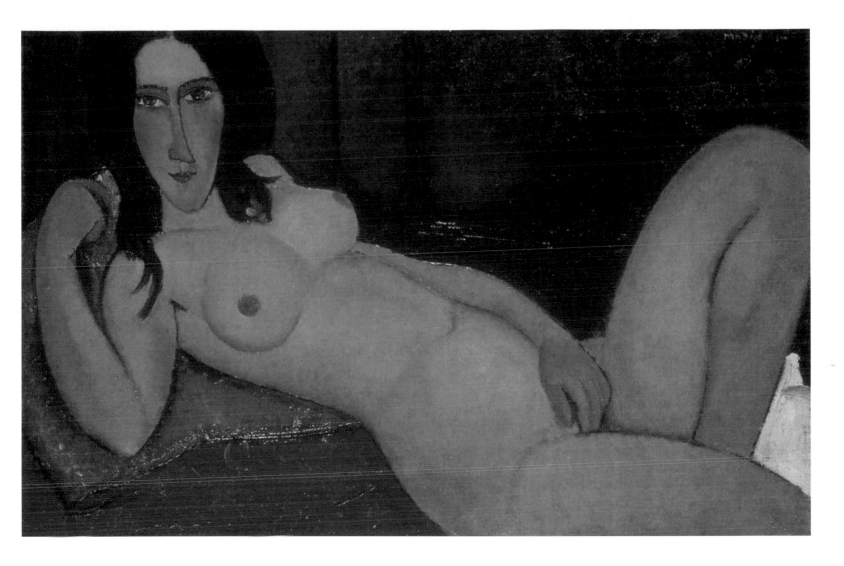

31. ***Reclining Nude with
Loose Hair***, 1917.
Oil on canvas,
60 x 92,2 cm.
Osaka City Museum
of Modern Art, Osaka.

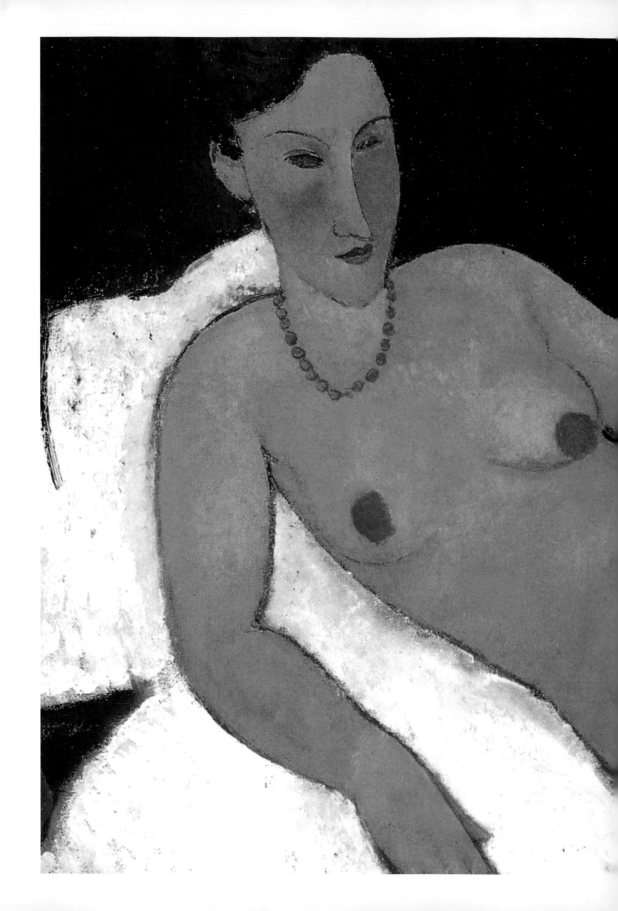

32. *Nude with Necklace*,
1917.
Oil on canvas,
64,4 x 99,4 cm.
Allen Memorial
Museum, Oberlin,
Ohio.

An Unconscious Liberation

Goya's *Maja Desnuda* (1798–1805) had caused consternation because it depicted a real and well-known lady of the court. Modigliani adapted the composition for many of his nudes, for example *Nude with Necklace* (1917, p.43), *Nude* (1919, p.44), and *Sleeping Nude with Arms Open (Red Nude)* (1917, p.38) but Goya's painting has an aloof air and is deliberately posed, and so has a formality that is familiar from High Art. Modigliani avoids formal compositions, settings, and technique, so his nudes have a wildness and freedom that make them modern and striking.

Manet's *Olympia* (1863) was criticized when first shown, mainly because the model was an ordinary Paris prostitute, not considered a worthy subject for art, but also because she is gazing directly and openly at the viewer. This forces viewers to admit that they are admiring a prostitute, rather than allowing them to pretend that seeing a nude was an almost unintentional consequence of following a literary narrative or deciphering an allegorical scene. There is no ornate landscape or richly-drawn fabric to put Modigliani's *Nude* (1919) in a mythological or pastoral setting, even though she lies obliquely across the canvas with her right arm behind her head in a pose like that of Giorgione's *Sleeping Venus* (c.1508).

Nude on a Blue Cushion (1917, p.49) also borrows the pose of *Sleeping Venus*, but she is not demurely sleeping, unaware that she is being watched. Her full red sensual lips highlight both her attractiveness and her desire. This makes her more vivid and tangible than *Sleeping Venus* despite being less realistic in style. Manet's *Olympia* challenged the observer to enter into a visual transaction with the prostitute gazing back out of the picture, but the blue eyes of Modigliani's figure add to this challenge a disconcerting surrealism. Her blank eyes stare, but stare blindly, so she is both confronting the viewer and remaining oblivious.

Eyes were a potent image in symbolism as the "mirrors of the soul," representing introspection as well as observation. Modigliani was a keen reader of Symbolist poetry, often reciting verses from memory, and would have seen symbolist works by such artists as Odilon Redon (1840–1916), Edward Munch (1863–1944), and Gustave Moreau (1826–1898) at the Venice Biennial Exhibition in 1903.

33. ***Reclining Nude***,
1917.
Pencil on paper,
26 x 41 cm.
Private collection.

34. ***Nude with Necklace***,
1917.
Oil on canvas,
73 x 116 cm.
Solomon
R. Guggenheim
Museum, New York.

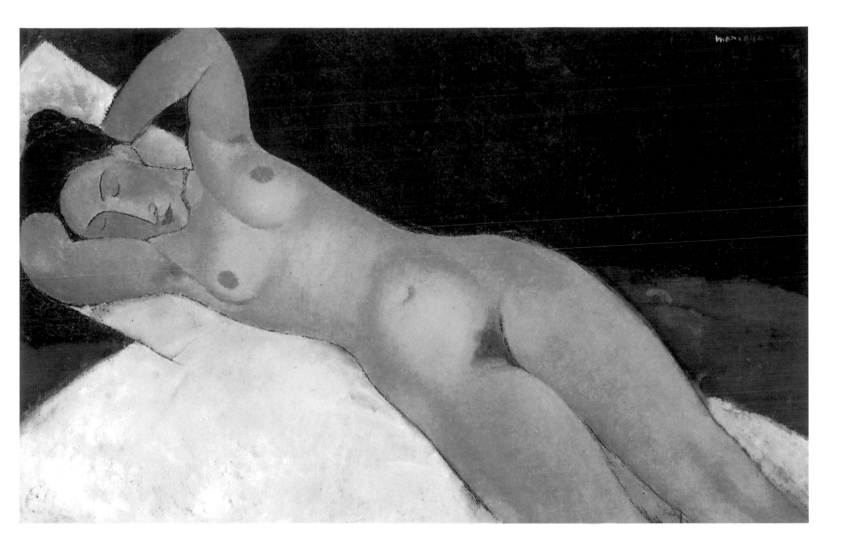

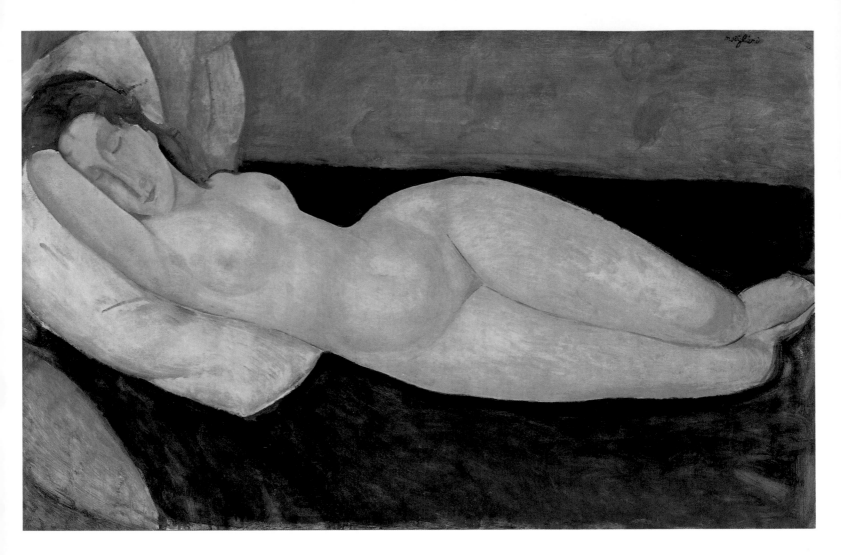

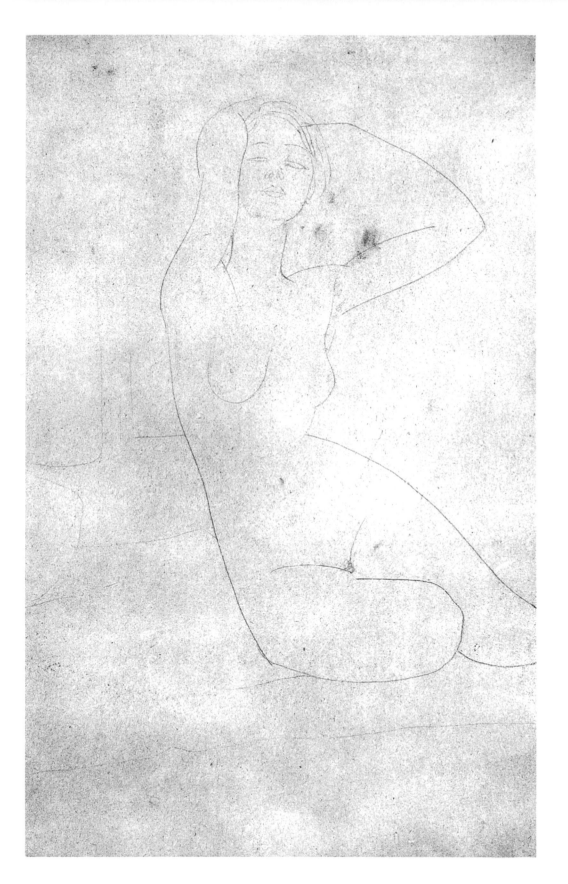

35. **Nude**, 1919.
 Oil on canvas,
 73 x 116 cm.
 Private collection.

36. **Seated Nude**, 1918.
 Pencil,
 14,1 x 27,9 cm.
 The Museum of
 Modern Art,
 New York.

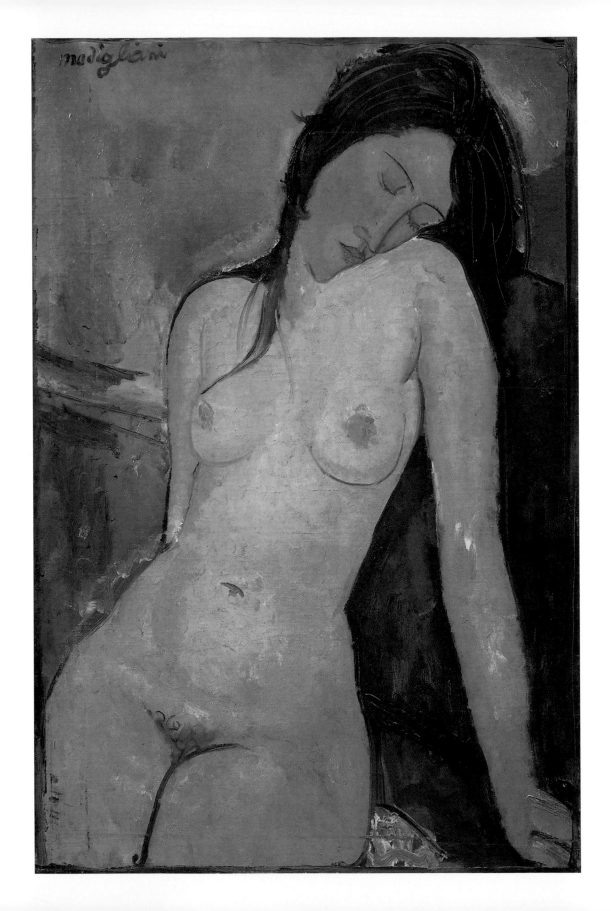

The gaze of Modigliani's empty-eyed nudes is perhaps their most unnerving feature, in contrast with both the passive and comforting averted or closed eyes of most classical nudes and Olympia's bold but recognizable stare.

The cold, disinterested expression of *Nude Looking Over Her Right Shoulder* (1917) makes her seem annoyed that she is being watched. It is like the look of someone who has turned round to discover her photograph is being taken.

She shares, in reverse, the pose of Venus in *The Toilet of Venus* (c.1645–1648) by Velazquez, but unlike Venus, who stares only at her own reflection, she is looking out of the picture, at the viewer.

Meanwhile Modigliani draws the gaze of the viewer to her full hips and buttocks at the focus of the composition. The story goes that Modigliani met the ageing Impressionist Pierre Auguste Renoir (1841–1919), who described painting one of his pictures as repeatedly caressing the buttocks of the nude; Modigliani retorted rudely that he did not like buttocks. Indeed, most of his nudes are viewed from the front, and perhaps this explains some of the untypical tension of his painting.

Modigliani does not identify his models, so they may represent goddesses or prostitutes. The images therefore have to be considered purely in their own terms for they make no obvious social or political comment. This decontextualizing, however, was highly political in a society that was still largely governed by 19th-century prudery and strict social hierarchies.

Representations of nudity were considered morally acceptable only if they were presented according to the traditional artistic formulas which distanced the images from everyday life. This enabled people to enjoy looking at nudes while maintaining repressive attitudes towards sexuality in general. Modigliani was not a social elitist and considered the beauty and sexuality of ordinary women to be neither shameful nor an unworthy subject for great art. He does not add details or backgrounds to his nudes that would show them to belong to a particular social class or role.

This discourages the observer from making moral judgments about the status or lifestyle of the figures and so promotes a purely aesthetic approach. Such disregard for the old systems was threatening to those who feared female sexuality and bohemian liberality.

37. *Seated Nude*, 1916.
Oil on canvas,
92 x 60 cm.
The Courtauld
Institute of Art
Galleries, London.

38. *Seated Nude*,
circa 1917.
Pencil,
31,2 x 23,9 cm.
Mr. and Mrs.
W. Alsdorf, Chicago.

Manet's *Olympia* caused outrage because it celebrated a confident and unashamed prostitute; most of Modigliani's nudes are not coy and demure like Giorgione's *Venus* or Titian's nudes. Their attitude, along with the reduction of narrative and subject matter to nothing but the erotic body, presented for its own sake, were considered scandalous. It is ironic that these works by Modigliani, who deeply respected and wanted to belong to classical tradition, were seen not as High Art but as outrageous depictions of naked women.

The police, who closed down his first and only solo show, held at the Berthe Weill gallery in 1917, expressed horror that Modigliani had painted the models' pubic hair, a tiny detail that nonetheless flouted artistic conventions. Earlier artists, such as Gustave Courbet (1819–1877), had taken delight in painting with such realism, but had not been allowed to show such work in public.

Modigliani did not see his nudes as the indulgence of private fantasies, and so did not see why they should not be put on public display. Clearly, a great many people agreed.

It was the crowd that came to see his show that drew the attention of the police. Modigliani's exhibition was closed down not simply because his paintings were deemed immoral but because they were popular.

One of the first in his series of nudes, *Seated Nude* (1916, p.46), may be a portrait of Beatrice Hastings, an eccentric English writer with whom Modigliani had an affair from 1914 to 1916. She was very supportive of him, especially when he returned to painting having finally given up sculpture because of the expense of the materials and the irritation that the stone dust caused his lungs.

The *Seated Nude* was certainly created with her encouragement. The outline is less sure than in later works: it is uneven and broken, and the head with its sharp chin sits rather awkwardly. The down-turned face functions to direct the viewer's gaze to the centre of the canvas and the centre of her body.

The fall of hair emphasizes the shape of the breast, and the delicate gradations of colour mark out the full roundness of the curves of her belly.

39. ***Nude on a Blue Cushion***, 1917.
Oil on canvas,
65,4 x 100,9 cm.
National Gallery of
Art, Washington D.C.

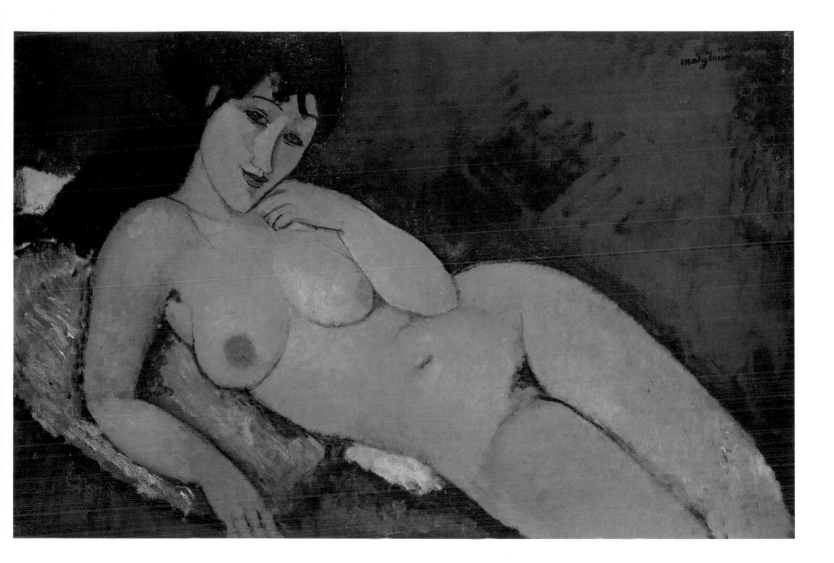

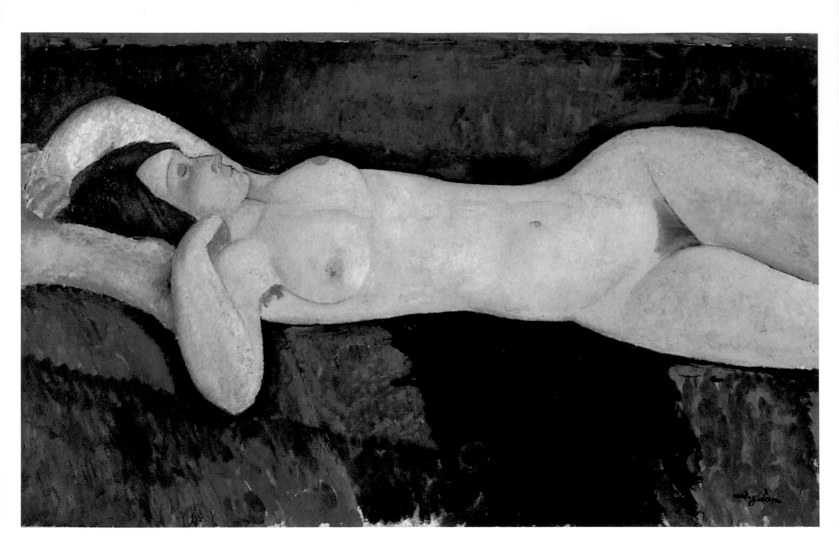

She forms an elegant oblique across the canvas, the light to the left and the dark to the right, with just enough attention to the background to frame the figure without defining the space. Modigliani's attention to detail is only apparent in a few places, notably the pubic hair. The glowing use of colour gives the body a vibrancy while the model herself sleeps.

The nude sketch *Seated Nude* (1918) also has a somewhat uncomfortable pose, with a dramatic twist to the stomach, an exaggerated *contrapposto*, and unresolved lower thigh. However, the feel of motion and a youthful softness created by the delicacy of the curves give the figure a warmth and charm. The detailing in the upturned face is just enough to give her a sensuous, blissful air.

The *Seated Nude* (c.1918, p.56) is distorted and mannered, showing a Cubist influence. The shoulders, legs, and buttocks are not fully drawn, and the asymmetrical eyes make the image strange and less instantly appealing than *Seated Nude* (1918).

However, there is a languid charm to the tilted head and the slackness of the body exudes relaxation. This conveys a dream-like eroticism that is all the more potent for its subtle portrayal.

A similarly odd atmosphere pervades *Nude on a Blue Cushion* (1917, p.49). Modigliani again does not complete the modelling of her legs but shows careful observation of the form of her breasts. Her quizzical and enchanting expression make her seem awake and lively but her eyes are nonetheless unreal, so her seductive gaze is timeless and undirected. The heavy plasticity of her body owes much to Modigliani's experience of depicting the caryatids: her form is majestic and sculptural, while the composition is photographic – her legs and the top of her head cut-off and "out of shot."

The Art of "Close-Up"

Modigliani often takes a very close viewpoint for his pictures – far closer than most earlier painters of nudes. This was no doubt due to the influence of the new medium of photography, especially the erotic photography that was coming in vogue. His use of this technique heightens the sense of physical presence of the figure and the artist's proximity to the model.

40. ***Reclining Nude (Le Grand Nu)***, circa 1919. Oil on canvas, 72,4 x 116,5 cm. The Museum of Modern Art, New York, Mr. and Mrs. Simon Guggenheim Fund, 1950.

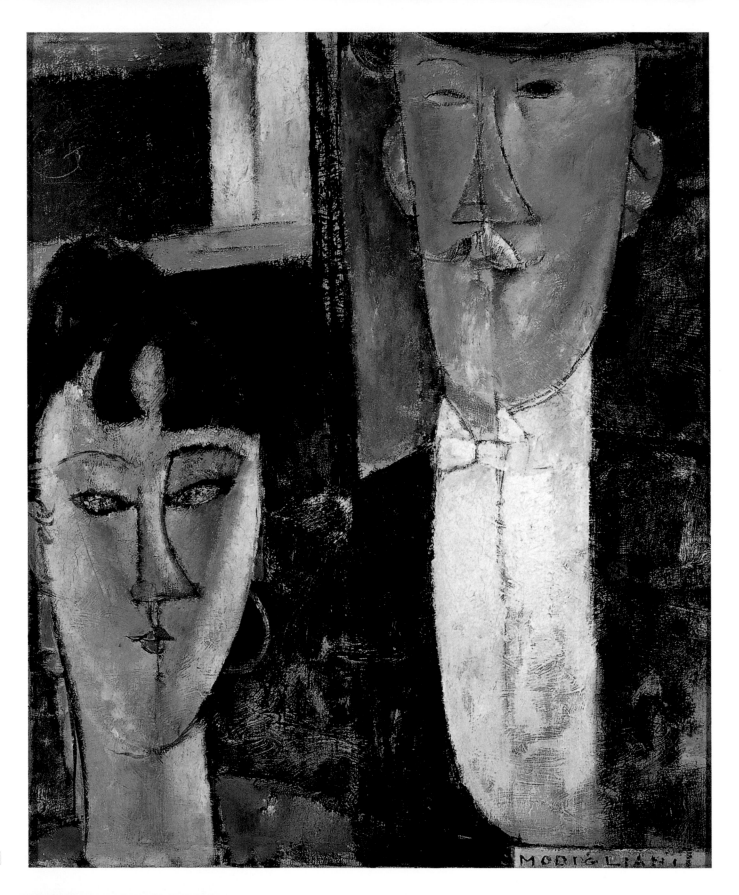

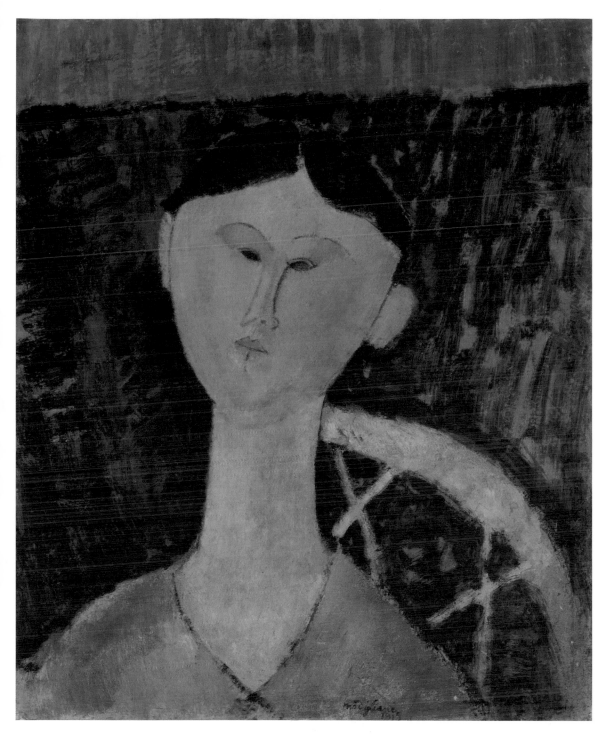

41. ***Bride and Groom***,
 1915.
 Oil on canvas,
 55,2 x 46,3 cm.
 The Museum of
 Modern Art,
 New York.

42. ***Portrait of Beatrice
 Hastings***, 1915.
 Oil on canvas,
 55 x 46 cm.
 Art Gallery of
 Ontario, Toronto.

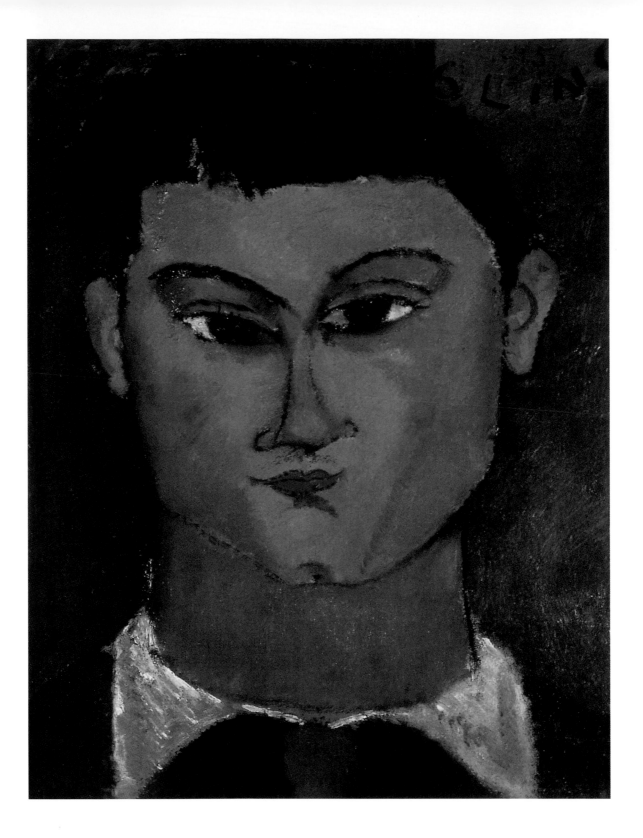

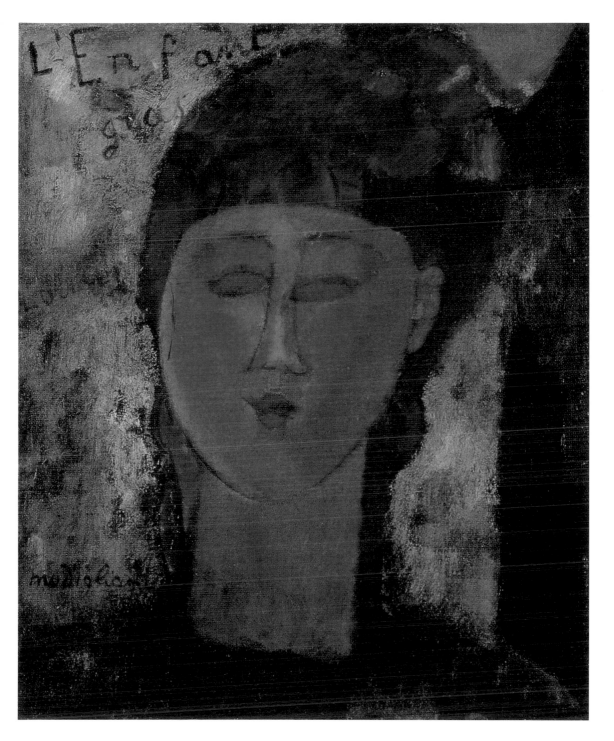

43. *Portrait of Moïse
 Kiesling*, 1915.
 Oil on canvas,
 37 x 29 cm.
 Pinacoteca di Brera,
 Mailand, Donation by
 Emilio und Maria Jesi.

44. *L'Enfant gras*, 1915.
 Oil on canvas,
 45,5 x 37,5 cm.
 Pinacoteca di Brera,
 Mailand, legacy of
 Lamberto Vitali.

Modigliani cuts short the legs of almost all his nudes and many also have part of the head or arms cropped to create a snapshot effect. This device is particularly striking in *Sleeping Nude with Arms Open* (*Red Nude*) (1917, p.38).

By placing the model's body in the centre of the picture as if it is bursting out of the frame, Modigliani accentuates only the sexual aspects of the figure. Absolutely nothing else is of interest. The snapshot style makes the figure accessible as well as utterly dispensing with traditional rules of completeness in composition. Despite the careful brushwork and skilled use of delicate tonal variation, the overall effect is of effortless spontaneity – the complete opposite of the traditional notion that quality is the same as scholarly studiousness.

The spontaneous flamboyance of Modigliani's nudes made them appear all the more brazen and shameless to conservative eyes. The open enjoyment of the erotic that appears in his paintings was reflected in the sexual liberty of Modigliani's own life.

Even as a teenager he had a reputation as a seducer: when he was an art student in Venice he apparently spent more time in cafés and brothels than attending courses and in Paris he had numerous lovers, although there is little evidence and much speculation about his liaisons. He was said to have slept with all of his models, some of whom were well-known in the artistic community, Kiki, the Queen of Montparnasse, Lily, Massaouda la négresse, Elvira, the wild young runaway daughter of a Spanish prostitute, and Simone Thirioux, who bore him a son.

However, there are no nude paintings definitely identifiable as Elvira or Simone, and only one sketch that is definitely Beatrice Hastings. It is likely that he paid some professional models without having sexual relationships with them, and that he painted some of his lovers who were not professional models.

By the end of his series of nudes, Modigliani had reached the zenith of his style. He suggested volume with elegant arching arabesques and had achieved the utmost in simplification and abstraction. For example, *Reclining Nude* (p.50) shows Modigliani's full command of line.

The outline is even and precise. The distortion of the hips is non-naturalistic but not jarring and hints at, rather than proclaims, the figure's sexuality.

45. *Seated Nude*,
 circa 1918.
 Pencil,
 42,5 x 25 cm.
 The Art Institute,
 Chicago.
 Given by Claire Swift
 Markwitz in memory
 of Tiffany Blake.

46. *Reclining Nude*,
 1918.
 Oil on canvas,
 73 x 116 cm.
 Galleria Nazionale
 d'Arte Moderna,
 Rome.

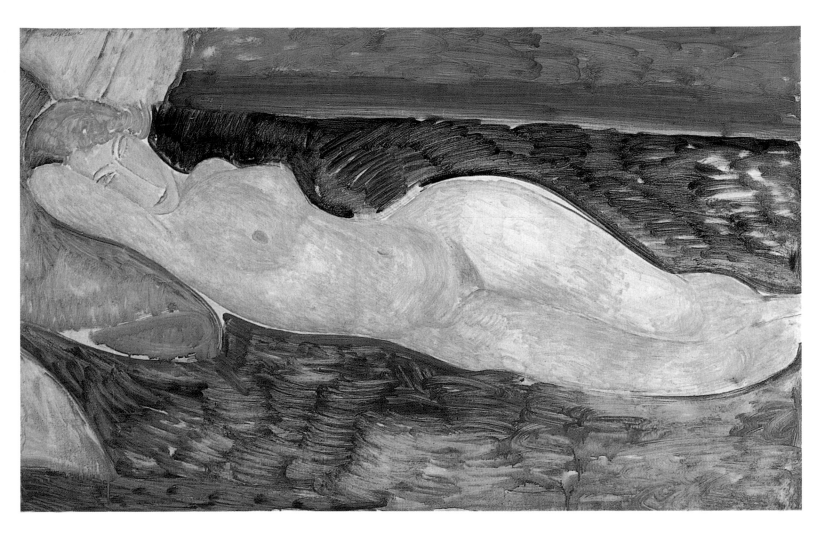

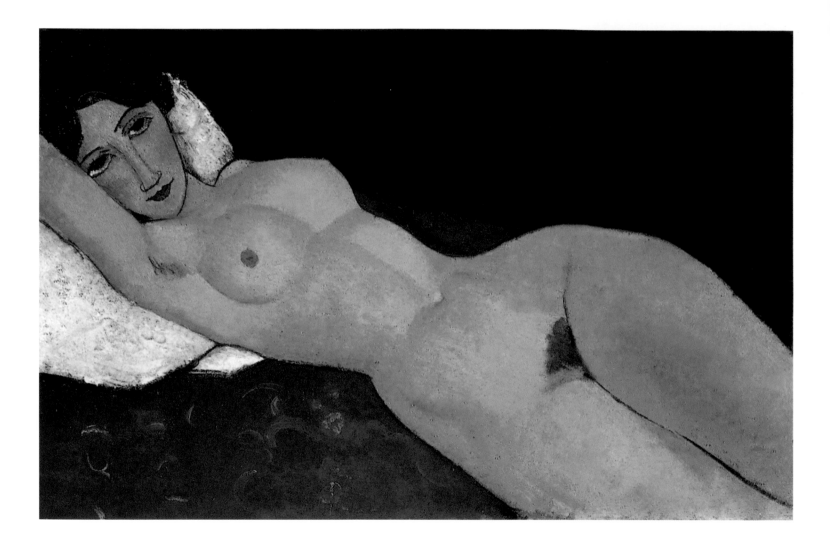

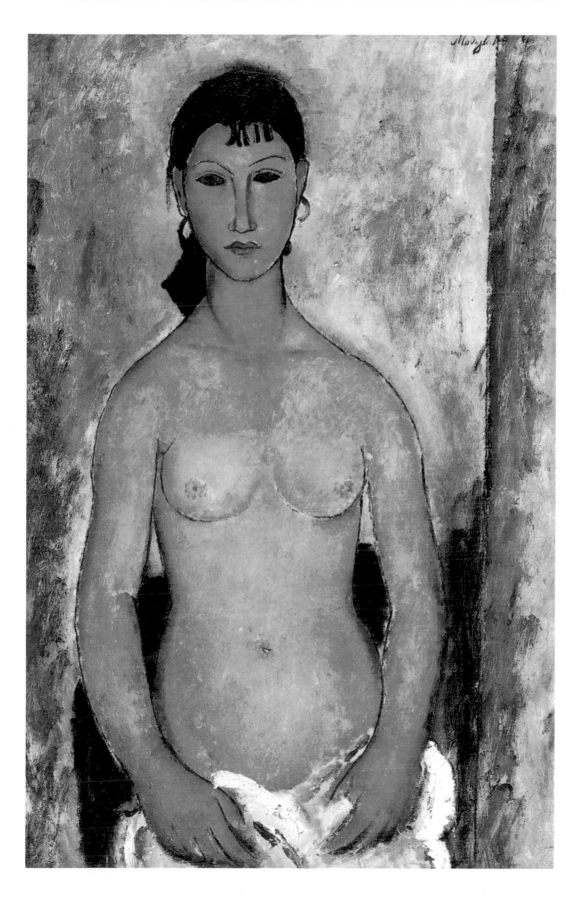

47. **Reclining Nude**,
1917.
Oil on canvas,
60 x 92 cm.
Staatsgalerie,
Stuttgart.

48. **Standing Nude
(Elvira)**, 1918.
Oil on canvas,
92 x 60 cm.
Kunstmuseum Bern.

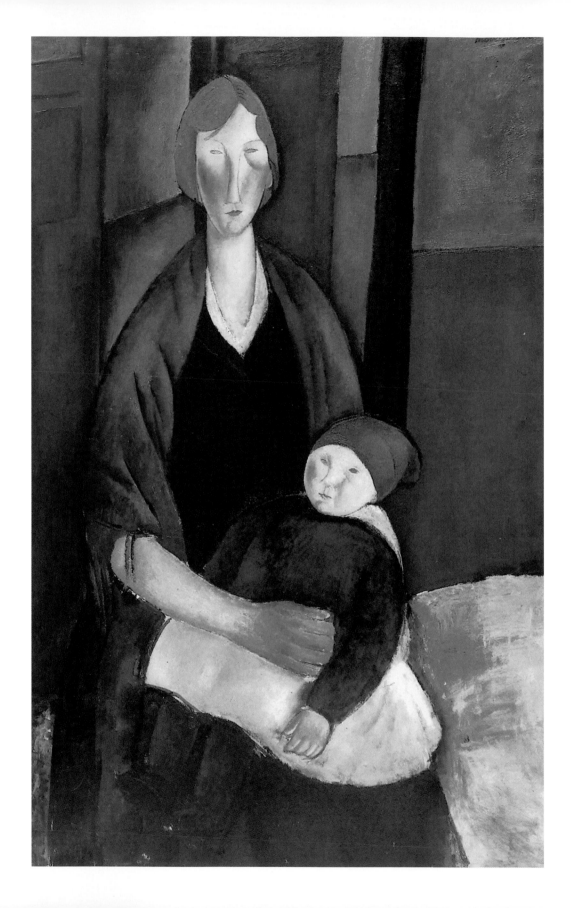

He has used a restrained palette, which gives the picture an air of tranquillity, and the artist's hand is masked by an ease of execution and delicacy of brushwork that adds to the transcendent atmosphere. She is bathed in a gentle light, and subtle tonal changes mark out her form so lightly that she appears to float against the dark background.

The *Standing Nude* (*Elvira*) (1918, p.59) is called *Elvira* although Modigliani's affair with her had ended several years earlier. The model holds a folded cloth just low enough to suggest that she is completely naked, but this echoes, and perhaps even parodies, the suggested modesty of the great classical nudes.

She has a rigidly geometric pose and her full breasts are almost perfect hemispheres. Her blank gaze has a sense of boldness and is totally still. This gives her a monumental sculptural quality. The eroticism appears suspended and her personality is frozen. She is like a stone statue: not a real woman but merely a physical form, reified and depersonalized. Again, the absence of background detail adds to the timelessness of the image.

Emotional Involvement
A Depersonalizing Process

Despite depicting his models as particular individuals, Modigliani makes surprisingly little attempt to engage with them emotionally or to portray them psychologically. He maintains an objectivity and a distance as artist, especially in his later nudes, and does not overtly attempt to solicit any specific emotional reaction from the viewer. This allows the viewer a freedom of response, but also distances the artist from any direct involvement in that response.

Censors even as late as the 1940s and 1950s saw the paintings as obscene and pornographic, but Modigliani was not deliberately setting out to provoke such a response. Modigliani's unrepressed sexuality enabled him to express his desires with a carefree joy that borders on innocence. He was neither afraid of the sexuality of the models nor of his own libido, and so his nudes are not contaminated by the petty emotions that social oppression and mean-spirited moral condemnation encourage. For centuries, sleep had been a way of alluding to sexual fulfilment and many of Modigliani's models, especially the later nudes, are asleep.

49. *Seated Woman with Child*, 1919.
Oil on canvas,
130 x 81 cm.
Musée d'Art Moderne,
Villeneuve d'Ascq,
France.

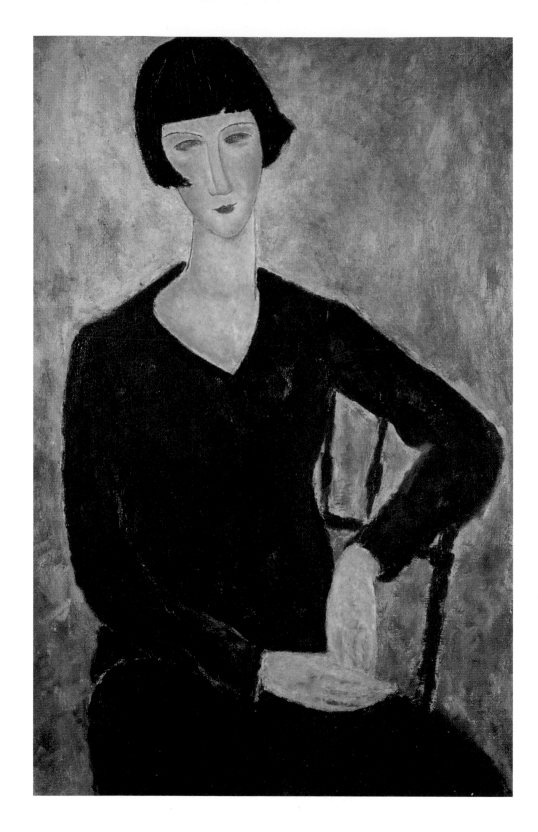

50. **Seated Woman in Blue Dress**, 1917-19. Oil on canvas, 92 x 60 cm. Moderna Museet, Stockholm.

51. **Little Girl in Blue**, 1918. Oil on canvas, 116 x 73 cm. Private collection.

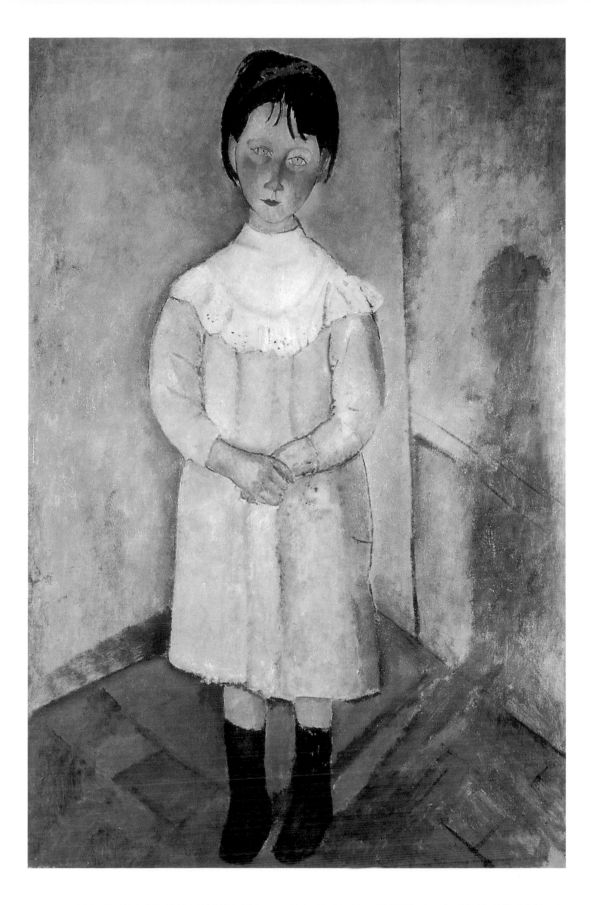

Those that are awake appear calm and unconcerned or have blank eyes and are lost in an introspective world, undisturbed by the observer. Modigliani is primarily interested in the shapes of the bodies of the models, not their characters, and the blank or closed eyes emphasize this disengagement. Blank eyes also represent the inner-directed gaze and introspection that fascinated Modigliani; they also constitute a comment on the nature of voyeurism and observation.

Unlike Edgar Degas (1843–1917), who almost always tried to show his models as unaware that they were being watched, Modigliani sometimes makes it clear that the model is looking back at the viewer, as does the *Nude Looking Over Her Right Shoulder* (1917).

Modigliani was also seeking to go beyond images of individuals to convey a timeless and eternal quality outside of everyday social morality and behaviour. This idea was inspired by the classical concept of beauty but also chimes with Cézanne's abstraction and reduction of complex forms to their simplest essences. Chaim Soutine said of Cézanne, "Cézanne's faces, like the statues of antiquity, had no gaze."

Picasso, too, had looked away from the depiction of particular individuals in his studies of abstract African sculpture, hoping to find something more enduring in an image than the ephemera of one moment of one person's life. Modigliani's depersonalizing of his images can also be seen as part of this artistic aim, especially evident in the portraits that he painted while in the south of France, which include twenty-five of Jeanne Hébuterne. He said, "What I am seeking is not the real and not the unreal, but rather the unconscious, the mystery of the instinctive in the human race" (Doris Krystof, *Modigliani*).

An Aesthetic Quest

52. ***Portrait of Jeanne Hébuterne with Large Hat***, 1917. Oil on canvas, 55 x 38 cm. Private collection.

Modigliani's yearning for perfection in shape and form became an almost Platonic quest to find the essence of beauty beyond the attractiveness and sensuousness of the individual. He began to concentrate on balance, harmony, and continuity of form and to lessen the emphasis on heavy plasticity. He wanted to combine the solidity of sculpture with a weightless luminosity of colour and an elegance of line. This aesthetic aim went far beyond the expression of the eroticism of any single figure.

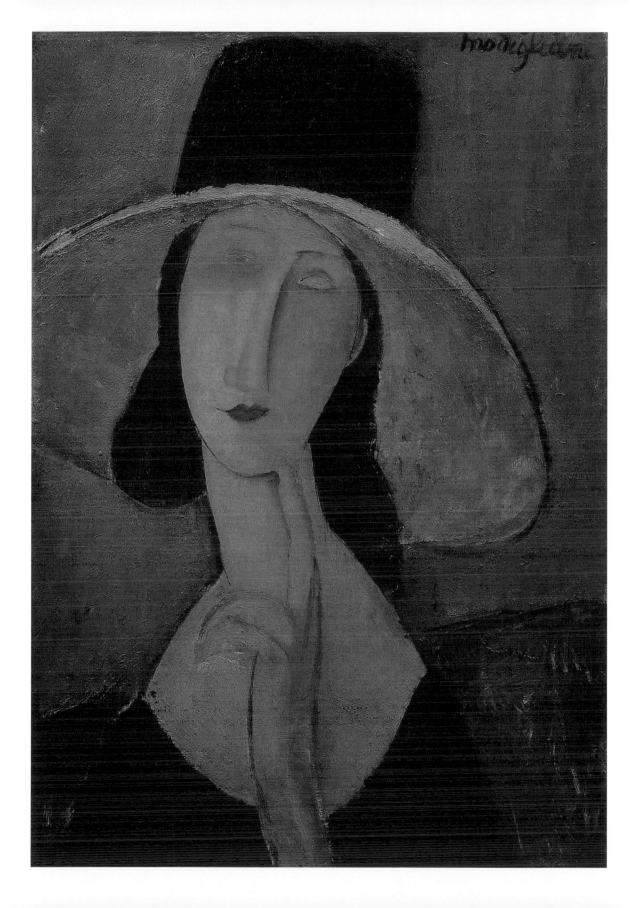

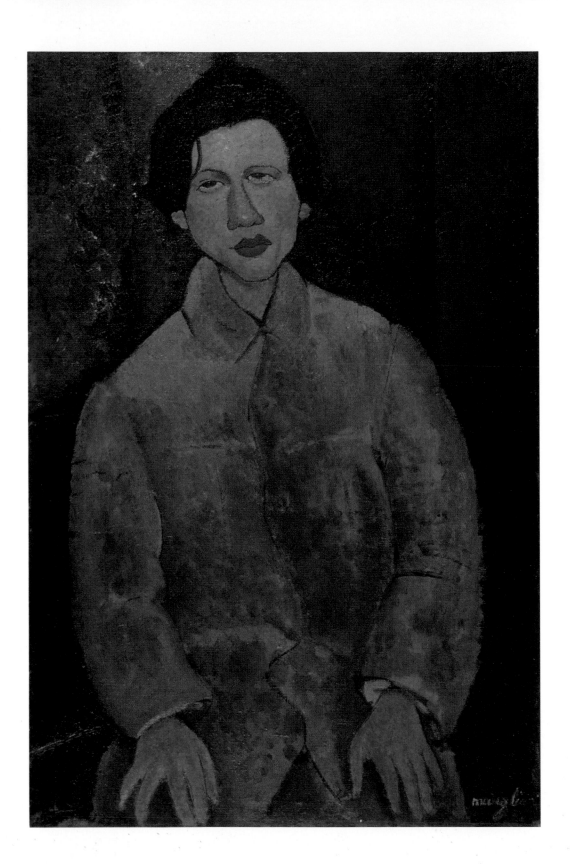

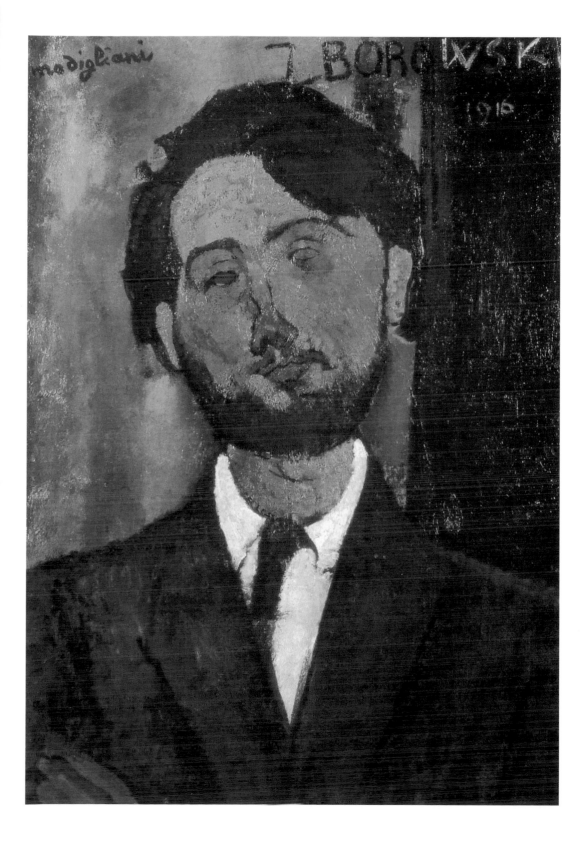

53. *Portrait of Chaïm
Soutine*, 1916.
Oil on canvas,
100 x 65 cm.
Private collection.

54. *Portrait of Leopold
Zborowski*, 1916.
Oil on canvas,
65 x 43 cm.
Private collection.

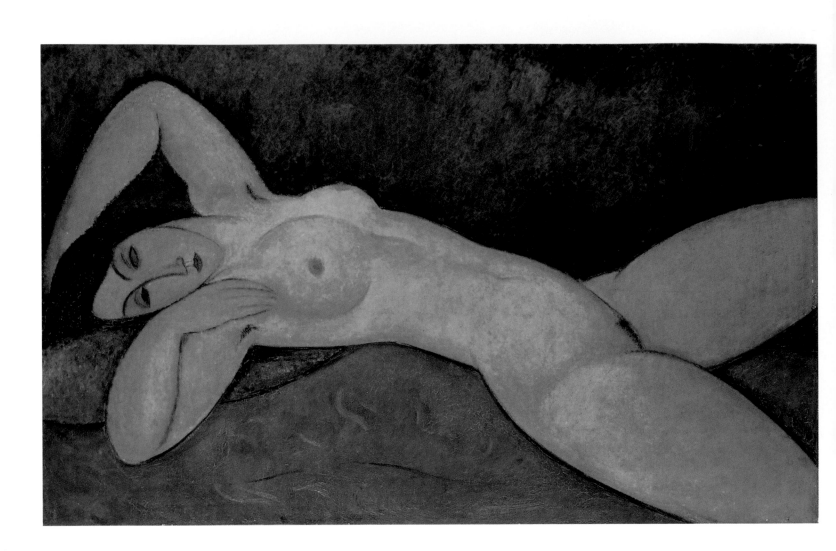

The culmination of this endeavour can probably best be seen in his *Nude With Necklace* (p.42), *Reclining Nude (Le Grand Nu)* (c.1919, p.50), and in *Nude* (1919, p.44). Modigliani's skill as a colourist and his precision of line are both evident, especially in *Reclining Nude (Le Grand Nu)*.

The detailing of the breasts and pubic region is more restrained than in earlier nudes, inspiring a gentler but less fleeting erotic response. *Standing Female Nude* (c.1918/1919) has a floating grace and the detailing focuses on her face. The swinging line and full curves of her breasts are anatomically accurate, while Modigliani's mastery of line enabled him to use the fewest lines necessary to depict solidity.

By the end of his series of nudes he had mastered the depiction of the sensuality and attraction of the individual and had removed unnecessary idiosyncrasies to reveal only the abstract aspects of beauty. Having explored sexuality on a personal level he looked for the transcendent desire beyond the individual response, and was able to step back from the frenzied carnal intensity of his earlier works to create a less personal and so less evanescent eroticism.

His success in transforming the erotic energy and allure of one model at one point in time into an image that conveys the universality and endurance of human sexuality is perhaps Modigliani's greatest artistic achievement.

Conclusion

Modigliani's love of traditional Italian art and his view of himself as working within and developing this tradition meant that his nudes were not intended to be radical or confrontational.

However, he could not avoid his perceptions being affected by the avant-garde art that was being produced around him and he was inspired by similar influences. This led him to draw together the ancient and the modern, the traditional and the revolutionary. It was this blending of old and new, along with the intensity of his passion and his desire to express himself freely, that enabled him to create a new and unique vision. Despite the tragedy that often accompanied his own short life, his nudes are joyous and appealing and have remained some of the most popular in modern art.

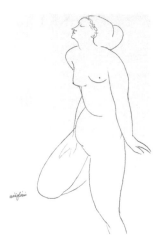

55. *Nude*, 1917.
Oil on canvas,
72 x 117 cm.
Private collection.

56. ***Standing Female Nude***, circa 1918/19.
Pencil,
39,5 x 25,5 cm.
Private collection.

57. **Portrait of Jeanne
 Hébuterne**, 1918.
 Oil on canvas,
 100 x 65 cm.
 Norton Simon Art
 Foundation, Pasadena,
 California.

58. **Portrait of Jeanne
 Hébuterne**,
 circa 1918.
 Oil on canvas,
 100 x 65 cm.
 Private collection,
 Zurich.

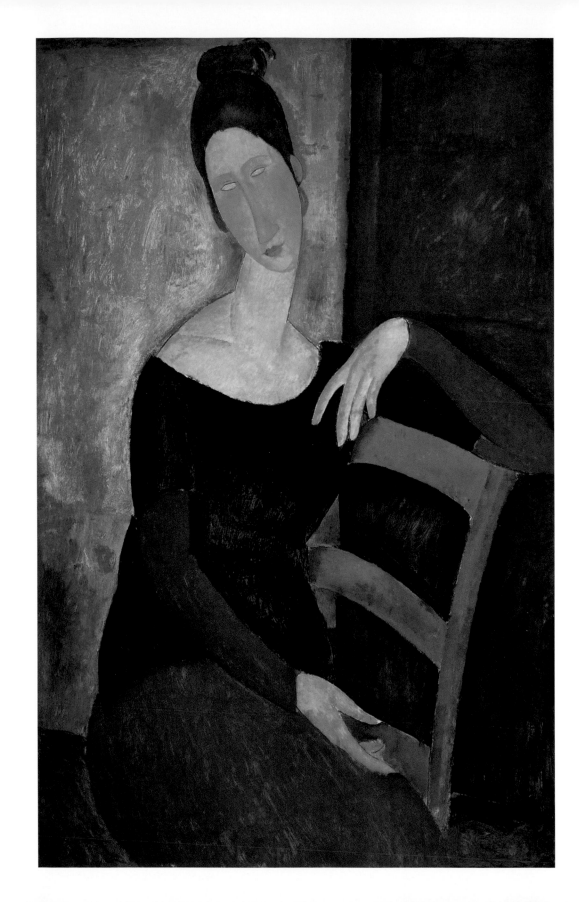

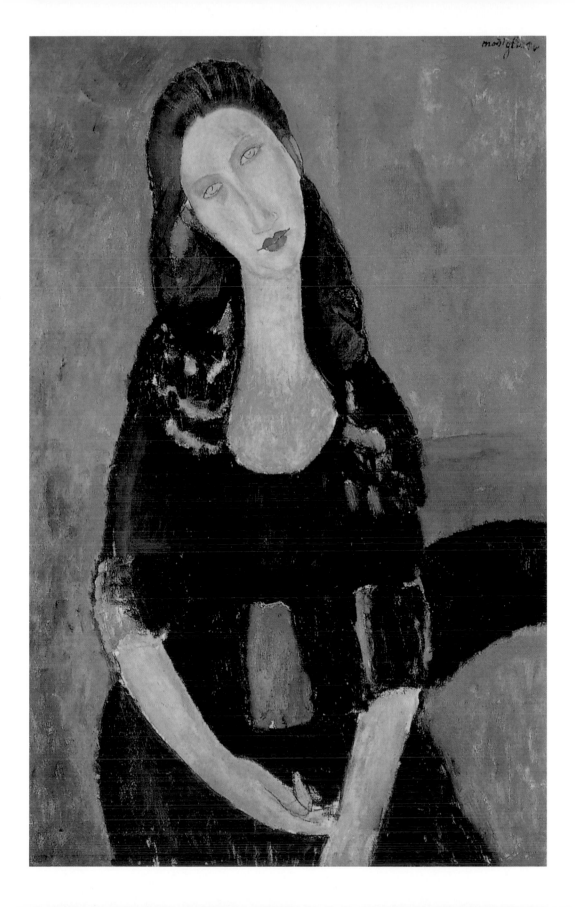

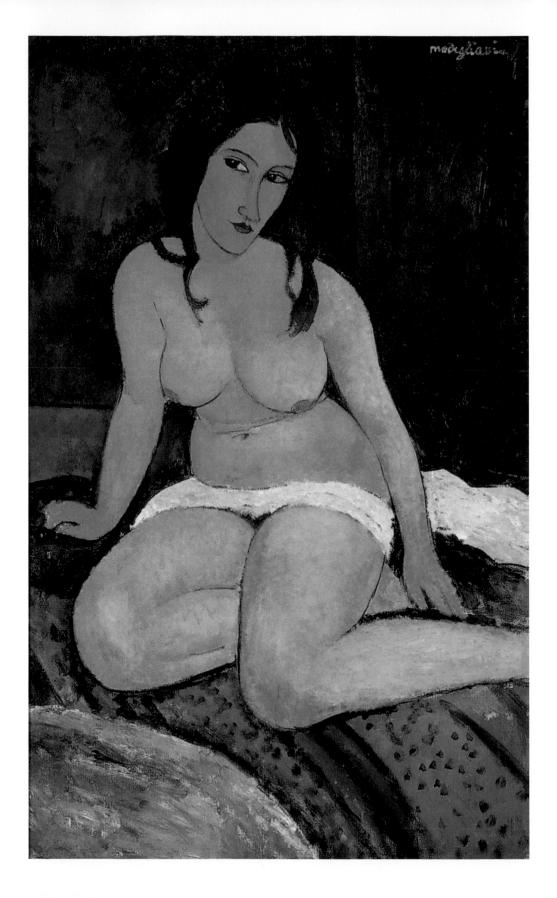

Biography

1884

Amedeo Clemente Modigliani is born on July 12 in Leghorn, a town on the Italian coast in the province of Lovorno. The youngest of four children, he receives a Jewish education. Since early childhood, he suffers from health problems and consequently undertakes many trips for convalescence. He thus gets to know southern Italy as well as the museums and cathedrals of Rome and Naples that introduce him to the art of the Italian Renaissance.

1898

Modigliani enters the art academy in Livorno. His teacher Guglielmo Micheli makes the 14-year old familiar with impressionist art.

1902

At the Scola Libera di Nudo dell'Accademia de Belle Arti in Florence, he establishes ties with the Tuscan impressionists around Giovannu Fattori. Travelling around Tuscany raises his interest in sculpture.

1903

In March, Modigliani enrolls at the Scuola Libera del Nudo in Venice. At the Biennial expositions, he is especially fascinated by Cézanne and van Gogh. French painting – the works of Henri Toulouse-Lautrec in particular – inspires him to go to the centre of avant-garde art, Paris.

1906

Modigliani settles in Paris (initially in Montmartre) and takes drawing lessons at the Accademia Colarossi. He completes more than 1000 sketches during his studies. His dissipated lifestyle, characterised by affairs, drugs and alcohol, quickly renders him infamous in the district. His circle of acquaintance includes reputable artists and literary figures, such as Pablo Picasso, Guillaume Apollinaire, André Derain and Diego Riviera. He is moreover closely associated with Jewish intellectuals and artists like Max Jacob, Chaim Soutine and Moïse Kisling.

59. *Seated Nude*, 1917.
Oil on canvas,
73 x 116 cm.
Koninklijk Museum
voor Schone Kunsten,
Antwerp.

1907

The artist gets to know Dr. Paul Alexandre, who is the first to buy his pictures. The doctor enables Modigliani to exhibit in the Salon d'Automne. Already at this stage, the painter is predominantly working on portraits and nudes. He becomes a member of the Société des Artists des Indépendants.

1908

Amedeo exposes six of his works at the Salon des Artistes des Indépendants.

1909

Modigliani moves to Montparnasse, the real heart of art in Paris, and makes the acquaintance of Constantin Brancusi, who introduces him to sculpture. Sculpting becomes Modigliani's preoccupation; a new style is meant to promote an air of solidity. He steals the material for his figures from unattended building-sites. For health reasons, he resumes travelling to Italy.

1910

The sculptures displayed at the Salon des Artistes des Indépendants receive excellent criticism.

1911-12

Modigliani exhibits sculptures and paintings in the studio of Souza Cardoso and again at the Salon d'Automne. For health reasons, he prefers painting (mainly portraits) to the exhaustive task of sculpting.

60. *Young Man (The Student)*, 1919. Oil on canvas, 60,9 x 46 cm. The Solomon R. Guggenheim Museum, New York.

1914

His work is represented at the exhibition "Twentieth Century Art" at the Whitechapel Art Gallery in London. Around the beginning of the first world war, he loses touch with his patron Dr. Alexandre. Due to his tendency to attract chest infections, he is spared from serving in the war.

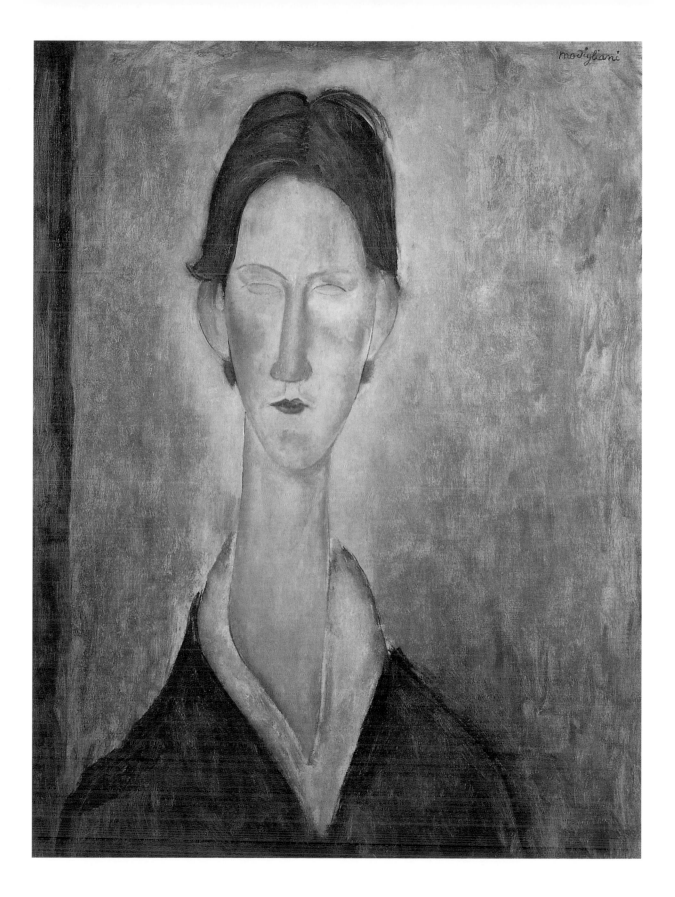

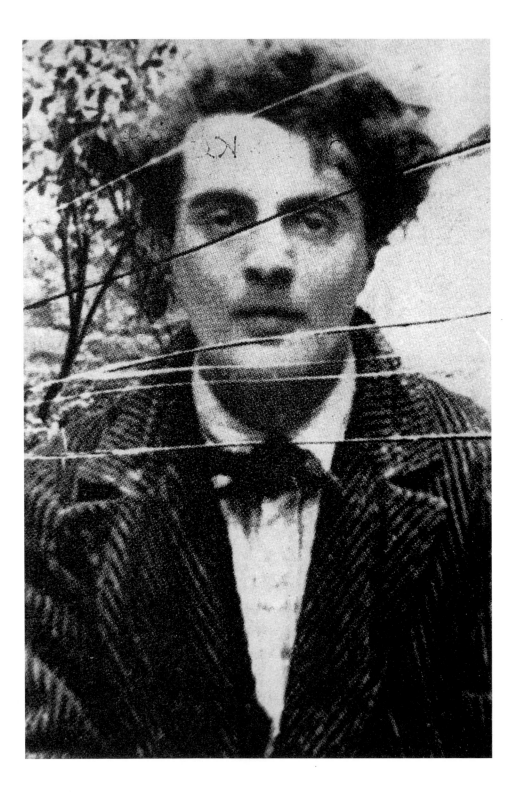

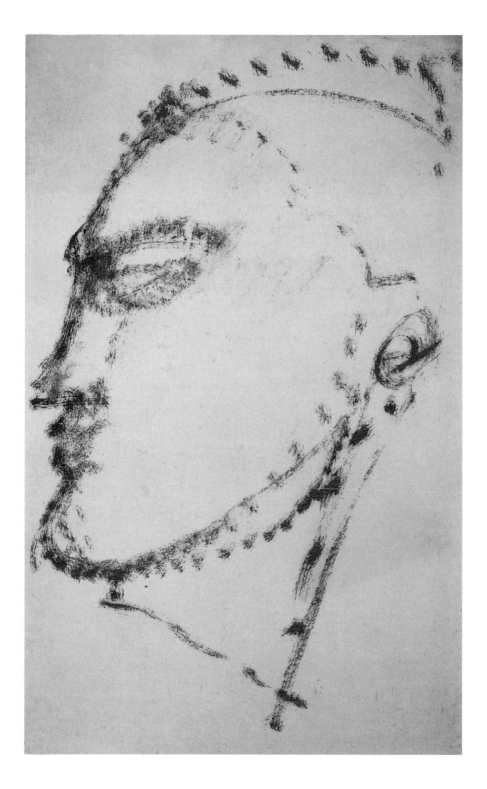

61. Modigliani at his
 arrival in Paris in
 1906.
 Photograph, archives
 Billy Klüver.

62. *Profile of man*.
 Oil on paper.
 42 x 25 cm.
 Private collection.

1914-16

Amedeo gets to know the English poet Beatrice Hastings and lives with her for two years. He finally turns his back to sculpting. Up to 1916, art dealer Paul Guillaume buys several of his works, but Modigliani remains poor. He prefers to paint his friends – for a little money or some alcohol. To pay his meals, he peddles his sketches in bars and cafes.

1916

He meets Leopold Zborowski. The Polish poet would like to turn Modigliani into an artistic celebrity.

1917

With Jeanne Hébuterne, with whom he is to remain until his death, the artist calms down. He commences his first series of nude studies (although he sketches neither Jeanne nor Beatrice Hastings as a nude). Modigliani's first individual exhibition at Berthe Weill gallery in Paris produces a public outcry and is closed down by the police on the day of its opening.

1918

His progressive tuberculosis forces the couple to retire for a year to the Cote d'Azur. Their daughter Giovanna is born in November.

1919

The family returns to Paris. He is again represented at numerous exhibitions. His health, however, deteriorates rapidly – in part due to his excessive alcohol consumption.

63. Amedeo Modigliani, Pablo Picasso and an unknown in August 1915. Photograph, archives Billy Klüver.

1920

Unconscious, Modigliani is taken to hospital and dies on January 24 at the age of 35. The following day, his companion Jeanne commits suicide in an advanced state of pregnancy.

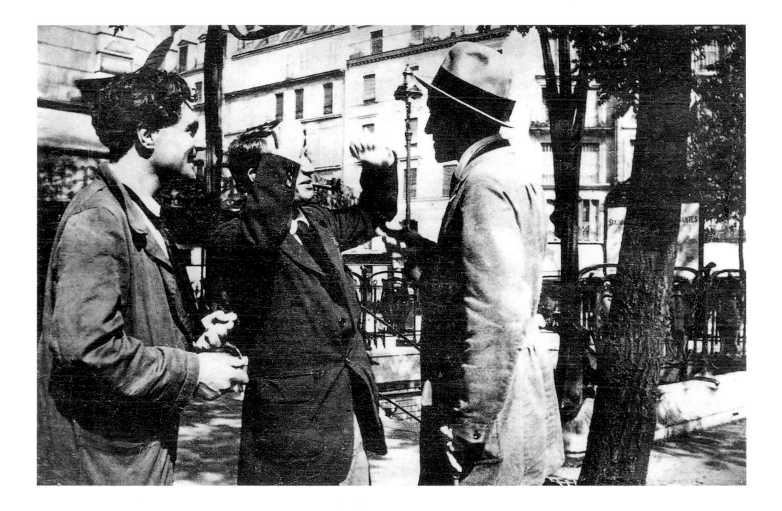

LIST OF ILLUSTRATIONS

1. Self-Portrait, 1919. p. 4
2. Landscape in the Midi, 1919. p. 6
3. Tree and Houses, 1919. p. 7
4. Nude, circa 1908. p. 9
5. The Beggar of Livorno, 1909. p. 10
6. The Cellist, 1909. p. 11
7. Portrait of Jeanne Hébuterne - Head in profile (Young Redhead), 1918. p. 12
8. Female Nude with Hat, 1907-08. p. 13
9. Caryatid, 1913-14. p. 14
10. Red-Haired Young Woman in Chemise, 1918. p. 16
11. Seated Nude with Necklace, 1917. p. 17
12. Sheet of Studies with African Sculpture and Caryatid, circa 1912/13. p. 18
13. Caryatid Study, circa 1913. p. 19
14. Idol. 2700-2400 BC. p. 20
15. Standing Figure, circa 1912/13. p. 21
16. Head, 1911-13. p. 22
17. Caryatid, 1914. p. 23
18. Standing Nude, 1911/12. p. 25
19. Standing Nude with Garden Background, 1913. p. 26
20. The Red Bust, 1913. p. 27
21. Blue Caryatid. p. 28
22. Caryatid, circa 1914. p. 29
23. Caryatid, circa 1912/13. p. 30
24. Caryatid, 1911/12. p. 31
25. Caryatid, circa 1912. p. 32
26. Caryatid, 1913. p. 33
27. Nude (Nudo Dolente), 1908. p. 34
28. Pink Caryatid, 1913/14. p. 36
29. Caryatid. p. 37
30. Sleeping Nude with Arms Open (Red Nude), circa 1917. p. 38
31. Reclining Nude with Loose Hair, 1917. p. 39
32. Nude with Necklace, 1917. p. 40
33. Reclining Nude, 1917. p. 42
34. Nude with Necklace, 1917. p. 43
35. Nude, 1919. p. 44
36. Seated Nude, 1918. p. 45
37. Seated Nude, 1916. p. 46
38. Seated Nude, circa 1917. p. 47
39. Nude on a Blue Cushion, 1917. p. 49
40. Reclining Nude (Le Grand Nu), circa 1919. p. 50
41. Bride and Groom, 1915. p. 52
42. Portrait of Beatrice Hastings, 1915. p. 53
43. Portrait of Moïse Kiesling, 1915. p. 54
44. L'Enfant gras, 1915. p. 55
45. Seated Nude, circa 1918. p. 56
46. Reclining Nude, 1918. p. 57
47. Reclining Nude, 1917. p. 58
48. Standing Nude (Elvira), 1918. p. 59
49. Seated Woman with Child, 1919. p. 60
50. Seated Woman in Blue Dress, 1917-19. p. 62
51. Little Girl in Blue, 1918. p. 63
52. Portrait of Jeanne Hébuterne with Large Hat, 1917. p. 65
53. Portrait of Chaïm Soutine, 1916. p. 66
54. Portrait of Leopold Zborowski, 1916. p. 67
55. Nude, 1917. p. 68
56. Standing Female Nude, circa 1918/19. p. 69
57. Portrait of Jeanne Hébuterne, 1918. p. 70
58. Portrait of Jeanne Hébuterne, circa 1918. p. 71
59. Seated Nude, 1917. p. 72
60. Young Man (The Student), 1919. p. 75
61. Modigliani at his arrival in Paris in 1906. p. 76
62. Profile of man. p. 77
63. Amedeo Modigliani, Pablo Picasso and an unknown in August 1915. p. 79